THE REVOLUTION WILL BE TELEVISED

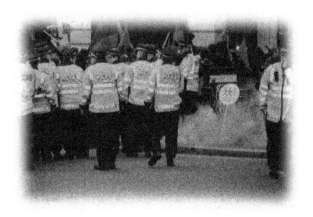

The revolution will be televised.
By Ray Stuart
© 2023
Photo by Ray Stuart

ISBN: 9781739363871

Published by Earth Island Books
Pickforde Lodge
Pickforde Lane
Ticehurst
East Sussex
TN5 7BN

www.earthislandbooks.com

First published by Earth Island Books 2023

Printed and bound by Solopress, Southend.

therevolution@email.com

"There is no revolutionary tradition in England, and even in extremist political parties, it is only the middle-class membership that thinks in revolutionary terms."

George Orwell
The English People

Contents

Dedication

In September 2022, Thérèse Coffey MP began her brief reign as health secretary and deputy prime minister to Liz Truss. One of her first acts was to send a memo to staff at the Department of Health and Social Care asking them to avoid using the Oxford comma.

Around her the country was on the verge of economic collapse, working people faced a cost-of-living crisis, Covid recovery wasn't anywhere near complete, Brexit and the pandemic left severe staffing crises in many industries, the NHS and care sector were on their knees, and the sleaze of Boris Johnson's corrupt government hung in the air, so it stands to reason that the first thing Thérèse chose to tackle was discretionary grammar.

This book is dedicated to the good folk of the world, those who want change, who feel stymied and beaten down by the system, and to the Oxford Comma.

Foreword

By James Domestic James Scott, Sudbury, March 2023.

When Ray asked me to write the foreword for this, his latest book, it naturally led me to think about how we came to know each other, which then forced me to face the fact that I've known him a full two decades. This makes me feel bloody ancient; although I'm still considerably younger than him, and always will be.

Anyway, pushing aside my bruised vanity for a moment or two, our story begins in housing. Social housing to be precise. I grew up in a seaside town that had been in serious decline since the mid-eighties, and eventually escaped, for want of a better word, a couple of years into the new millennium. My new job – my first office job, after several post-school years of flitting between the factory and the dole – and spur to move, was at a housing association in Colchester, Essex. Being a left-leaning music geek, and a bit of a piss-taker, I naturally gravitated towards Ray, and one or two others. Even a few years down the line when we'd both left the company, and I'd moved over the border into Suffolk, we'd stayed in touch.

Ray, and his then-girlfriend (now wife), Ali, would host vinyl nights at their house every couple of months or so, where a bunch of us would take an assortment of records to play, get drunk and eat chilli.

Sometimes, either as a stand-alone event, or as an addendum to a vinyl night, they'd host a touring acoustic act in their living room. Either way, they were great nights, and much-missed when the call of the road turned them for a while into camper van itinerants.

Another time, Ray decided he was going to put on a gig for Damo Suzuki, the erstwhile singer for German 'krautrock' legends, CAN. I was duly roped in as advisor, due to my long, and ongoing, history of playing in numerous bands. My tasks were accompanying him on visits to potential venues, and pulling together a heavily-improvisational backing band. I should add that, at this time, Mr Stuart had never promoted a gig in his life; he just fancied doing it – an attitude to life that we share. Never let a lack of experience get in the way of a good idea!

When he first mentioned the subject of this book to me, I was immediately interested. Coming from a background of the underground hardcore punk scene and having played at many squat venues across mainland Europe, I have been exposed to what some people might term 'radical' politics for many years. The fact that, in actuality, the majority of these ideas only appear radical because it's in the interests of mainstream politicians to label them such, is another matter, and one I have no space to expand upon here.

However, this book seems to me – and Ray may disagree, as is his privilege – to be aiming at a somewhat less subcultural audience. I'm sure that I know people that would consider the ideas in this book too 'soft' or not drastic enough. People that could pick ideological holes in the use of some of the terminology within.

But those people would miss the point entirely. Life, and the politics that runs through our lives like 'Clacton' through a stick of rock, shouldn't be some kind of ideological pissing contest; the (re)introduction of ideas, and the framing of them in a personable, thoughtful, but none-too-precious way, may provide an enjoyable gateway for readers to whom dry (supposedly) radical texts might be a leap too far from a standing start.

If you're expecting something akin to the writings of Marx or Bakunin here, then this book may disappoint. If, however, you'd like to relax with something akin to meeting Ray in a bar and having a good old chinwag about the state of the nation, picking up some facts, some ideas, and maybe some new perspectives, in an honest, unpretentious way, from an all-round good bloke, then stop reading this drivel and get stuck into chapter one; you'll like it.

James Domestic
Sudbury, 2023

James Domestic is a songwriter, musician, member of too many bands to list (but most notably/obviously, The Domestics), DJ, poet, painter, and anything else he fancies having a stab at.

www.jamesdomestic.com

Introduction

"The action of introducing something."

This book comes from a place of despair.

Like so many I've grown up convinced that we can do better, as individuals, as communities, as a nation, and as a species.

Despite many examples of all the lovely people I've been privileged to meet in 60 years orbiting the sun, we seem to remain mired in the same merry-go-round of boom-and-bust economics as left and right, or increasingly right and far right, use working people as pawns in their power games.

Meanwhile, a class born of privilege and belief in their inherent right to rule, from Buckingham Palace to the House of Lords and Parliament, the judiciary, church, and forces - both armed and civilian - apply rules for which we have precious little say in and even less power to resist.

In the past I longed for revolution. One day the masses of ordinary working people would have had enough and rise up. Latterly I have come to realise that if the shower of uselessness infesting Parliament of late wasn't going to trigger open rebellion, then nothing would.

Instead, I have decided to embrace my middle-classness. Whereas I used to be full of passion and rage, I'm now full of artisan bread and locally sourced cheese. Meat may be murder but so are my knees. I'm leaving the street fighting and statue tipping to the young.

What follows is an appeal, to people from all backgrounds, those sympathetic to free-thinking and anarchist philosophy, as well as to like-minded people who wish to see a better, fairer society without the reliance on the straightjackets of traditional left-right politics or inherited traditions that govern our behaviour, like the church and monarchy.

You probably won't agree with some of the arguments and observations, in fact I'd be surprised if you don't froth at the mouth at times, or at least let out a weary sigh. It hasn't been written as a cosy fireside companion, nor is it intended as a manifesto. I believe that safe, comfy arguments repeated to the already converted are redundant. Without challenge and debate nothing changes. The powers that be would much prefer us to argue among ourselves over nuance rather than accept our differences and combine to challenge them.

Initially I set out to write a critique of contemporary Britain under the elitist patriotism of the Boris Johnson administration and the complicity of the opposition in parliament. Since then, things have changed, as has the nature of this book. The tone has switched from anger through bewilderment and eventually into questioning why so many people just accept the status quo and what we might do to engage them.

I started out using the term anarchist, in the sense that Edward Abbey defined it in 'A Voice Crying in the Wilderness (1989).

"Anarchism is not a romantic fable but the hard-headed realization, based on five thousand years of experience, that we cannot entrust the management of our lives to kings, priests, politicians, generals, and county commissioners."

I'm equally comfortable with freethinker if you'd prefer, or just insert the adjective of your choosing. This isn't a book about labels, you might be a dyed-in-the-wool Conservative voter for all I know, and if you are, welcome. It may get a little uncomfortable from here on but it's nothing personal.

I wrote this as a series of essays and placed them in an order that makes sense to me but could be shuffled around with little effect on the message, so feel free to dive in where you want. You're an anarchist after all.

I am not an academic. I acknowledge that there may be grammatical quirks and an approach to referencing that is idiosyncratic at best. If I had put as much effort into studying at school as I did discovering ways to avoid it, this might be a different book and grammar pedants would feel more relaxed in the presence of my writing.

Then again it is what it is, and like the punk movement that liberated me from stagnation in the 1970s, attitude is more important than ability.

Now that's out of the way, it's time to talk.

"It wasn't idealism that made me, from the beginning, want a more secure and rational society. It was an intellectual judgment, to which I still hold. When I was young its name was socialism. We can be deflected by names. But the need was absolute, and is still absolute."

Raymond Williams
Loyalties.
Random House.

What Revolution?

"A forcible overthrow of a government or social order, in favour of a new system."

In 2022 household energy costs escalated to ludicrous amounts, the cost-of-living spiralled ever upwards, interest rates rose sharply and, not to put too fine a point on it, were being dumped in the doo-doo thanks to unbridled capitalism doing what unbridled capitalism does.

The Conservative government, perhaps mindful of the risk of their core voters dying of hypothermia before the next election, intervened in ways guaranteed to get press coverage, without the need to do anything except ask a few civil servants to divert cash from one pot to another.

It was a token gesture, a bit of a rebate on your Council Tax if you lived in a home that doesn't have servant quarters and peacocks strutting about on the lawn, plus a promise of money off your utility bills, which in effect is a loan that'll be recouped by the energy companies over time anyway.

Oh, and they promised to cut taxes and then reversed that decision because the financial markets, the bedrock of fantasy capitalism, started to freefall and the Chancellor of just 38 tumultuous days, Kwasi Kwarteng was thrown under the bus a few days before the shortest serving Prime Minister of modern times was dumped.

Meanwhile energy producing companies like BP and Shell recorded record profits. These will be used to pay every customer's fuel bill for the whole of 2023. That is a lie.

Instead, it'll line the pockets of their shareholders. Shell got around paying any windfall tax in the UK because it had invested millions of pounds in its aging technology. Instead of feeding children they put the money into sexy new pipelines.

Throughout this debacle no one on the government or opposition benches has thought to mention that the problem is not escalating fuel bills, Covid-19 debts, the war in Ukraine or supply issues. It's rampant capitalism. That's what is causing hardship. Private companies can do what they like with their profits, without recourse to their customers or government.

Labour, the party of unions and people power (ahem) haven't seriously called for anything to change the obscene system of profit before people, except to ask in a rather courteous way for the sitting government to maybe, perhaps think about a slightly higher windfall tax if they get the time between parties, flying refugees to Rwanda and electing leaders.

Taking back our utilities into public ownership should have been an automatic response from Labour but, unsurprisingly with a knight of the realm at the top, they've fallen short. Again.

A revolution, political or social, hasn't occurred to the one party in a position to galvanise popular opinion and at least call for change. They haven't outlined any radical alternatives, just rehashed slightly less right-wing alternatives to the Conservatives. Nor has there been any serious, coordinated resistance beyond a few social media petitions and miffed letters to the papers.

Sadly, a popular uprising doesn't seem like an option right now.

So, this is less a call to arms, more a call to armchairs. To those of us who like a nice sit down and a cup of tea, to engage with middle England. A place where society has become increasingly binary in its thinking. From the debacle that is our first-past-the-post election system to the calamity of Brexit, we are supposed to accept a popularity contest as democracy.

Talking of popularity, many people still cling like frightened children to the concepts of a Royal family appointed by God, a state religion and two houses of parliament that are demonstrably corrupt. I've looked at these and other institutions that many of us take for granted; The monarchy, parliament and elections, class, and religion among them. There are a few sideswipes at other areas that illustrate how warped our collective thinking can become and how we've allowed policing ourselves on their behalf to become the norm.

When I started pulling all this together, Boris Johnson was Prime Minister and despite his obvious flaws looked set to remain there. His corrupt reign formed the backbone of my first draft, he was the embodiment of privilege and dishonesty masquerading as a cheeky chappie. An entitled fraud in an expensive suit.

Then he was usurped by his former allies in a move I'm trying not to take personally because it meant a hasty re-write, another in my long list of grievances against the Tory party. That aside, he is still a useful illustration of the powerful elite who think they should govern by right, so I've kept the chapter about him in, with a few amendments.

Then the Queen died, necessitating more re-writes amidst much harrumphing on my part. The only upside I can see is that if I keep mentioning Jim Davidson[1] maybe he'll pop his clogs too. One can hope.

The tone is light-hearted. We all need a bit of relief from the drudgery of the real world, and politically motivated writing is top heavy with sombre analysis and notably light on chuckles. As James said in his foreword, don't expect Marx, although if you really want Marx, Groucho may be nearer the mark than Karl. Which isn't to say I wish to make light of the awful state of our nation, and of the plight of people around the world. Maybe I just don't possess the vocabulary to adequately address all the ills of our world without resorting to a few cheap laughs.

As the revolution will be televised, it might as well be entertaining.

[1] If you don't know who he is, think yourself lucky. Or read the next chapter.

"An anarchist is someone who doesn't need a cop to make him behave."

Ammon Hennacy
The Book of Ammon
Wipf and Stock Publishers

Who's Who?

As one ages, cultural references used to explain a mindset, or as an example of good or bad attitudes, may get lost on a younger audience. In my case younger equates to many more people than I care to admit.

Some of those I'll be referring to should be well known, politicians like Boris Johnson for example. Other people like hoary old 'entertainer' Jim Davidson may not be so familiar.

Using a person to represent a class or type of character is probably a lazy way of working but acknowledging that hasn't stopped me doing it.

Boris Johnson MP - Former Prime Minister.

Liz Truss MP – Prime Minister for a calamitous interlude between Boris and Rishi.

Rishi Sunak MP – Former Chancellor, now Prime Minister who lost the first leadership race to replace Boris then got in when Liz Truss left office.

Sir Keir Starmer MP – Leader of the Labour Party and leader of the Opposition in Parliament.

Tony Blair – Former Prime Minister, the once great hope of the left who turned out to be anything but.

Gordon Brown MP– Former leader of the Labour Party and Prime Minister who was rather dumped in the doo doo when Tony Blair handed him the reigns.

Teresa May MP – Former Tory Prime Minister.

Margaret Thatcher. Former (now deceased) Tory Prime Minister. A divisive leader who decimated communities and won a state funeral.

Dominic Cummings – Former political advisor to Boris Johnson, arch strategist who fell out with his old boss and spilled the beans. No one knew which of the lying windbags to believe.

Jeremy Corbyn MP – One time leader of the Labour Party. Left wing and was elected, in part at least, by supporters of the Conservative party thinking it a jolly wheeze to join Labour and elect a socialist leader for them. He came close to winning the 2017 general election when Labour increased its share of the vote by 9.6%, a net gain of 30 seats, resulting in a hung parliament and the Tories forming a minority government.

Jacob Reece-Mogg – Conservative minister who likes to portray himself as an Edwardian Gentleman and guardian of old-school values but is in fact a clever and manipulative man hiding his contempt for the working class under a brocade waistcoat.

Queen Elizabeth II – The late Queen of the UK and Commonwealth.

King Charles III - The King formally known as Prince.

Andrew Wakefield - former doctor and academic who claimed a now discredited link between the measles, mumps, and rubella (MMR) vaccine and autism in 1998.

Princess Diana (Di) - First wife of Prince Charles. Died in a car accident in August 1997.

Sarah Ferguson (Fergie) – Ex-wife of Prince Andrew.

Camilla - Married to King Charles. Was known as Queen Consort to avoid offending Princess Diana's fan club.

Jim Davidson – Old school comedian of the mother-in-law and racist jokes variety.

Roy 'Chubby' Brown – Not unlike Jim Davidson but deliberately offensive comedian rather than just old fashioned.

Nigel Farage – Former leader of the United Kingdom Independence Party (UKIP). Hailed as a hero by some for engineering Brexit. Now hosts a show on fringe UK TV. It's been pointed out to me that he has a face like a constipated toad, which indeed he does.

Joe Wicks – A celebrity fitness coach who rose to prominence during the 2020 lockdown when his irritating presence got us off the sofa, in most cases to switch channels.

"Every State is a dictatorship."

Antonio Gramsci
Selections from political writings (1921-1926)

The State We're In

"A country or its government"

On the 23 June 2022 the London Evening Standard newspaper ran two stories on its front page. The first, emblazoned in maximum impact huge typeface declared: **FORGET A 7% RISE, STRIKERS WARNED.** This was a message to rail workers who had withdrawn their labour for three days in June of that year and had reached a stalemate in the RMT union negotiations with rail bosses and the government.

The second 'story' although that's a little misleading, was a portrait of the Duke and Duchess of Cambridge, known to their friends as William and Kate. The picture took up half the front page.

It's a perfect juxtaposition of the state, nay State, that we're in. A privileged couple whose contribution to our lives is at best to turn up at charity events and shake hands with the carefully vetted hoi-polloi, and a dispute where a union has carefully navigated its way through the government's many and various legal impediments and challenges and legally withdrawn its labour in an effort to get fair renumeration for its members and protect the safety of passengers and rail workers alike. The news media portrays it as if their demands are not only unreasonable but border on treason.

Also in the news that day, but unlike union bashing or royal worshipping wasn't worthy of the front page, were reports of the first significant Polio outbreak since 1984 spreading in London. Refuges (or migrants, depending on your news source) were being readied to fly to Rwanda in a deliberately provocative act by the government, while then Prince Charles of all people intervened, much to the exasperation of the right-wing press.

Meanwhile the country was headed towards recession as inflation climbed above 9%, the cost of living was fast outstripping our ability to afford the basics, and fuel poverty was biting as costs rocketed. Abroad, Russia and Ukraine were still locked in a bloody and bitter war, with civilian casualties mounting minute by minute, and there was a desperate call for aid in Afghanistan after an earthquake killed over 1000 people and injured close to twice that amount.

William and Kate are the perfect foil to the gritty reality of the working person in 2022 UK PLC. We were, and remain, under the most vacuous, Machiavellian, privileged government imaginable with a bunch of political lightweights taking up valuable seating opposite them. If ever a government deserved to be brought down by fair means or foul it's this lot. Yet somehow, they seem impervious to censure as they bob around like something unpleasant that just won't flush.

After so called 'party-gate', when it was revealed that Johnson's government had enjoyed much alcohol-fuelled frivolity while elderly people died alone and most of us were cut off from regular human contact, a further scandal, this time over Chris Pincher MP - an alleged sex predator - was handled so badly by Boris that one-time loyalists in his cabinet lined up to force him out.

There followed a leadership election played out on TV and in the papers as if anyone other than the 175,000 or so members of the Conservative Party had a say. They managed the neat trick of holding the elections in the glare of publicity and by doing so effectively became their own opposition, relegating Labour to third. It's like a supermarket selling its own brand washing up liquid under different names and thus forcing other brands out.

Meanwhile the Play-Doh knight Sir Keir Starmer made occasional, ineffective, statements that sounded more like a bored barrister defending a serial offender than the leader of the Opposition.

Even though Johnson was usurped by Liz Truss, who in turn was hurriedly replaced by Rishi Sunak, we'll use Johnson as our jumping off point to explore the world of privilege because his odious presence overshadows so much of what follows, and as an example of entitled toffs he's pretty much the archetype.

"Everyone should have an equal chance, but they shouldn't have a flying start."

Harold Wilson

Privilege

"An advantage that only one person or group of people has, usually because of their position or because they are rich".

I hate people.

Not you, obviously. You are an adorable pile of flesh arranged in a fashion that is pleasing on the eye and filled to overflowing with a delightful personality. Not only that, but you've also had the decency to buy, steal or borrow this book and that qualifies you for extra compliments, so well done you. Nice hair.

I've only met a handful of the 7.8 billion or so people who are currently drawing breath on Earth. Of that tiny group, my personal interaction beyond the basics required for a conversation about the weather is even smaller. Maybe 20-30 people.

That's an infinitesimally small percentage, so it is probably not correct to state that I hate the rest of the 7.8 billion people scuttling about their daily business. With one or two exceptions everyone I dislike beyond a reasonable level of tolerance is a stranger to me. I know them only through the media or by reputation.

And to be fair for a moment, they all put themselves purposely into the public realm for scrutiny, so I don't feel bad about hating every single one of the 37.2 trillion or so cells that make up their pitiful existence.

Case in point is the untidy bag of privileged testosterone, Alexander Boris de Pfeffel Johnson

Love him or hate him...you just can't trust the wily old Churchill-lite bundle of Toryism. Indeed, he is so untrustworthy that as I was completing this piece he was swamped by letters of resignation as the ships fled the sinking rat and then, just as I was applying the final full stop he resigned.

I'm not suggesting that it was an act of spite on his part just to force me to rewrite it, but if it were, we will be better off without him anyway. I'll take one for the team.

I've seen a few Prime Ministers come and go, Wilson, Heath, Callaghan, Thatcher, Major, Blair, Brown, Cameron, May, Truss and probably a few placeholders in there too brief to remember.

What most, nay I'd go so far as to say all, of them had in common was a sense of authority. I disagreed with most of them, some on matters of principle, others on detail, one because he had offensive eyebrows, and most simply because they had divisive policies that fractured our country, laid waste to sandy parts of the globe and ignored the rest of humanity, often including their own people.

They may have been unscrupulous murdering bastards, but everyone on that list could demonstrate dignity when duty required them to do so. They could, however much one may have hated what they represented, stand up and be counted.

Okay, maybe Teresa May danced liked a drunk Aunt at a wedding and Gordon Brown forgot how microphones worked, but on the world stage they took their place alongside Presidents and Heads of State as a representative of our nation without the danger of their trousers falling down or uttering some racist drivel disguised as a cheeky quip.

On the domestic front they carried a kind of weight, a presence that set them aside as Prime Ministerial, irrespective of their political leanings. Indeed Thatcher, whose reign shaped my politics, in that I detested her policies so much that I instinctively took the polar opposite position to her on principle, could be relied upon to break out the pearls and shake hands with world leaders without causing diplomatic ties to be severed.

I acknowledge that having a state to be head of is an anathema to many people in the anarchist community. This isn't about lofty idealistic dreams. Cold, hard reality suggests that our state will persist for a while longer and I believe that it is incumbent upon us to work towards change incrementally or risk wallowing in debate without altering anything.

The state will of course continue to churn out politicians from the same leaky mould for a while, which brings us back to that blustering caricature of self-serving privileged old Etonian with an ego the size of Belgium and the moral authority of soup, Johnson. Faced with the unenviable task of guiding, nay leading, his country through an unprecedented pandemic he prevaricated, flip-flopped and stuttered.

Being generous, he made tough decisions along the way and sometimes followed the science, albeit dragging his heels and pretending he was above it all. It was though, against the backdrop of scandal and sleaze from his own party. At a time when the nation craved unity and moral authority, his own ministers were lining their pockets, profiteering, and ignoring the restrictions they had placed upon the rest of the nation.

Under his gung-ho leadership millions of pounds was wasted on an ineffective trace and protect system, Government contracts were handed to friends and a string of Tory-linked firms. Over half of the £18bn spent on pandemic-related contracts was awarded without competitive tender, according to the National Audit Office[2], including a hefty £550,000 to a firm associated with Michael Gove and Dominic Cummings, and somehow Health Secretary Matt Hancock's former pub landlord won a massive testing contract.

Just when you thought the blond buffoon would be rumbled, in steps the knight in fathers-in-law's shining armour, Rishi Sunak, with a wad of our cash slightly smaller than the loose change he leaves on the nightstand at bedtime, and a new super-hero is born. With his easy-going charm, public-school manners, and ability to make our own tax money sound like manna from heaven, he was thrust into the political limelight as a perfect sidekick for bumbling Johnson. What could possibly go wrong?

While Johnson and Sunak were encouraging us to clap not care, or something like that, north of the border First Minister Nicola Sturgeon equipped herself with poise and a steadfast determination to outperform Johnson at every opportunity. Such was the fear her leadership engendered amongst her political rivals, including those in England, that when she stood up at a funeral wake and forgot to immediately put her mask back on, a minor oversight at best, it was greeted in some sections of the press as if she'd run amok injecting toddlers and with botulism from a rusty syringe.

[2] Investigation into government procurement during the COVID-19 pandemic, Nov 2020

In Wales, First Minister Mark Drakeford, a man who possesses the bearing of an allotment club membership secretary, dug his heels in and showed he had the ability to make decisions without prevaricating or tousling his hair in a rakish manner. Across the sea in Northern Ireland Arlene Foster led with trademark directness.

As a supposedly United Kingdom, we were being led by someone whose career was built on populist opportunism and patronising those he pretended to serve.

Johnson was lauded by those who one might assume were his enemies. He was loved by the moralising, imposing-their-values-on-everyone, right, the Daily Mail, Express, Times, brigades of white, might and right Waitrose classes and the disaffected *'he's a lad isn't he...'* working classes.

This even though he's been married twice, has 5, 6, or possibly more children, I doubt even he is sure, he has had at least four affairs that are public knowledge, and had a son by his girlfriend while still married to someone else. None of which is my business, but in the good old days it'd have the tabloids frothing at the mouth to discredit him.

He has lost jobs because he lied (as an intern on The Times, and again in Michael Howard's government) but still he gets elected. Imagine if a woman had come to the election with a similar track record, do you think they'd be in Downing Street now?

Like heck they would.

We humans seem to have a knack for finding validation for our bad decisions. Like the Christian right in the good ole' US of A who believed Trump was sent by God. He may have been a bit 'salty' in his speech and direct in his manner, but the almighty sent him as an orange prophet to drive out the demons of women, homosexuals, gun control and black presidents.

Think about it, the deity who picked Moses, Isaiah, Elijah and his own son, apparently picked Donald. There are those that believe much the same about Johnson. I've seen pleas for prayers to help him, not just when he was ill with Covid-19, but generally, in his crusade against all things that scare suburbia - change, brown people, political correctness, loud music, health and safety, young people, computers, cycle lanes, plant-based food etcetera.

Johnson has lied and schemed to find an office that fits his ego. And he succeeded. Take a few mistresses, use ethnic and homophobic slurs, openly court racists and generally bumble about until the right opening appears, then insert yourself into the gap like a liquid great white hope.

Don't think Johnson is opportunistic and deceitful? Name one policy the conservative government had going into the last election OTHER than Brexit?

Go on, just one.

Hard without a search engine to help? It should be, they had nothing to offer except Brexit. It was a Presidential style campaign where he avoided scrutiny by the media and refused to engage beyond his own team's choreographed press briefings.

Whatever your feelings on Brexit, 0.5% of the UK's gross domestic product went to the EU. The other 99.5% went on our own frivolities like pensions, welfare, health, education, justice, defence, housing and so on. We could argue about that, but within the existing big state system, those were the big spenders, not the EU.

But Johnson only spoke about Brexit and the supposed evil empire of Euroland, and then only to the chosen few. We were duped by an extraordinary mix of our own biases, arch scheming (I'm looking at you, Cummings) and the toadying conservative press and their hatchet job on the opposition. Well, that coupled with an ineffectual and conflicted opposition in parliament, but you know, what did you expect?

Once he got his fat ego splayed over the sheets of No 10, with a war to bluster through and having cheated death he was almost invincible.

Almost.

So long as he kept little Boris tucked away inside his Jermyn Street strides, evaded any of the blame for his poor decisions and mismanagement that caused unnecessary deaths from Covid-19, partied like it was 1999 without recourse to the law, lied, cheated, and strutted his arrogant bloated frame around in a cloud of mindless optimism and away from detail and policy he'd be just fine.

Until he wasn't. Competing egos, backbiting, and sending ministers out to lie for him finally brought down the house of cards.

The worrying part though is that just about everyone knew he was a rogue. Even his own people knew he lied and prevaricated, was dishonest and a ridiculous parody of a real Prime Minister, but still they supported him. He survived a vote of no confidence when the case against him was so overwhelming that even some of his former allies on the right of the right of the house were calling for blood.

Johnson is just a visible symbol of a pyramid of power, corruption, and privilege that towers over us, from the cabinet to the opposition to the Mayors and Executives that often blight our lives with the perpetual merry-go-round of authority in the guise of making our lives better or easier to navigate.

It's odd, isn't it? That they build on *how it's always been done* to power, push, pull and prod us, carrot and stick fashion, to where they want us to be. Mostly they aren't even aware, it's just from a lack of critical thinking and being hemmed in by a system that doesn't permit originality or deviance.

Meanwhile MPs, on both sides of the house, can lie with impunity in parliament. The Speaker of the House of Commons is not responsible for what is said on the floor of the house, except to the extent that they police procedure. It is not their role to determine the accuracy of a statement or response to a question.

MPs cannot accuse each other or lying either – it is specifically against Commons rules for them to point out one of them is telling porky-pies, although I suspect that its worded slightly differently on the vellum scrolls that regulate our governors.

Labour MP Dawn Butler found this out to her cost at the end of the 2021 session of parliament when she pointed out that Johnson was *"misleading this House"*[3] over statements on economic growth, nurses' bursaries, and investment in the NHS. All of which she could substantiate with facts and figures, but she was the one who had to leave the chamber, not the lying windbag who had knowingly misled the house.

It's the type of loophole they love. One may fib with impunity because moral authority is no longer a pre-requisite for parliamentary office, indeed lying and manipulation seem to be valued more than honesty and integrity.

Popping down to a party mid-covid isn't the worst crime in the world, it isn't even the worst crime committed by Johnson. His prevarication, lying and evasiveness about the whole affair though was the mark of a privileged man who believed himself above the rules he imposed.

And Mr Perfect Pandemic sidekick Rishi Sunak turned out to be a bit of a cad too, floating around Westminster while carrying an American Green Card for tax avoidance purposes. Oddly, it is a requirement for holding an American Green Card that you actually live in the USA, rather than, to give a random example, number 11 Downing Street, London, England.

His wife had to face up to the idea of 'British fair play' and pay her taxes, because as we all know fair play only counts once you're found out, paying the Exchequer around £30,000 to secure non domicile status in the UK to avoid, it turned out, taxes of around £20 million.

[3] Which he was.

In many Conservative circles there is a third party to consider when evaluating their Prime Minister's fitness to govern. Every superhero and his intrepid sidekick must have an arch nemesis, and in this case the spectre of eternal doom lurking in the shadows is...Jeremy 'Beelzebub' Corbyn.

Yup, the man who actually isn't lurking in the shadows and won't ever be hanging pictures of Marx and Lenin in the drawing room of number 10, is invoked like a bogeyman every time the Conservative government is publicly criticised. *'Well, think how much worse it would have been under Jeremy...'* they parrot.

After all, the best defence against a string of sociopathic lying egotistical Prime Ministers is to compare them with someone who didn't have the opportunity to prove themselves as PM, and furthermore is not going to do so. You might as well say *'well, Truss may be a total scumbag who has ruined the economy, and Sunak is completely out of touch with the real world but at least they aren't Myra Hindley or Vlad the Impaler, we dodged a bullet there Marjory...'*

Johnson is a prime example of the elite who know exactly what they are doing. He isn't a provincial town local councillor who is sincerely trying to do some good, albeit while inadvertently propping up the very system that prevents genuine change from occurring. He was bred on the playing fields and panelled classrooms of Eton to lead. To be a leader not of us, but over us.

Once in power, Johnson tried to cling to it because it was his by right, in the muddled port and cigar smoke way of his forebearers. He was a sweating puffing panting symbol of exactly why the system needs more than polite reform.

Step in Liz Truss. With Johnson as her predecessor, you'd think she could waltz in eating a spit-roast baby and plump her Armani clad posterior onto the still warm arse groove in the big chair at number 10 and the masses would still applaud and mop their brows with relief.

She may have come up via the Comprehensive School system (although she wasn't the first Tory Prime Minister to attend one, despite what she claims) but her malleable policies and lack of anything other than cold hard personal ambition saw her land in office like a desperate fish out of water. For a few delicious minutes I allowed myself the fantasy that she was a sleeper agent for an anarchist cell who was planted to destroy the money markets and demolish international capitalism from within.

Turns out she was just incompetent.

Step in Rishi Sunak, unopposed. He is a multi-millionaire who has much to gain personally from capitalism.

A state that allows such privilege to bubble up to the surface needs draining and replacing with something that will ensure it doesn't happen again. The challenge is, how do we find a way to change the system that places people like Boris, Liz and Rishi in power without chaos and avoidable loss of life through revolution? If revolution were to happen most of the system would crumble, not such a bad thing, indeed, I imagine it's something that we all want. The problem is that most working people would be adversely affected by it. Not just through inconvenience, but a crumbling economy would negatively affect healthcare, social care, food supplies and much else besides.

If you want that, fine and dandy, but I'm advocating a gentler, more nuanced approach.

Where does one start?

"Is not all the stupid chatter of most of our newspapers the babble of fools who suffer from the fixed idea of morality, legality, Christianity and so forth, and only seem to go about free because the madhouse in which they walk takes in so broad a space?"

Max Stirner,
The Ego and His Own
CreateSpace

Freedom of the Press

"Newspapers or journalists viewed collectively."

It was no oversight when several popular newspapers stopped publishing circulation figures during the 2020s. They were, after all haemorrhaging readers and were slow to face the growth in instant news via the internet and 24/7 television.

Then again, by 2020 most had stopped being newspapers in all but name anyway. Driven not by quality, analysis, or investigation, but by advertising revenue, they increasingly turned to hysterical headlines to sell more copies.

Sales had started to slump as other sources of news became available during the day, so father disappearing behind the Telegraph while mother boiled eggs and made his packed lunch was no longer the breakfast routine of suburbia. Add to that a generational polarisation as the typical newspaper subscriber is significantly closer to death than birth; in a nutshell their readers are dying along with the printed press they cling to like an inky comfort blanket.

According to the Audit Bureau of Circulations, who seem to know about these things, the Daily Mail lost over 260,000 readers between 2020 and 2022, and the *i* just over 74,500 in the same period. The Telegraph, Sun and The Times all stopped reporting their figures after 2020 and the Guardian in 2021. One assumes that wasn't because they were embarrassed about how well they were doing.

In its purest form a newspaper delivers impartial information in a timely fashion, summarising pertinent information and offering an opportunity for the thinking classes to head off to work informed about the issues of the day or to browse over on the evening commute.

In reality readers are presented with whatever the owner or editor cherry picks to put in front of them and it's done without any pretence of impartiality. That may, in a world of freedom of thought and expression not be altogether bad, except for the charade they keep up of being a source of news rather than organs of biased and partisan opinion.

Examples are plenty and I have used one in the opening chapter, but the Daily Mail's back-peddling over Liz Truss is just too delicious not to share. They'd supported her during the election for leadership (more about this later on) so when their front-page headline celebrated Kwasi Kwarteng's mini budget with, **"AT LAST! A _TRUE_ TORY BUDGET"** no one should have been surprised.

As it happened that budget caused financial markets to lose faith in the UK economy and the aftershocks are still rumbling on, and as ever the working person trying to support themselves and their family are worse off as a result. In a way the Daily Mail got it right, it was a true Tory budget.

Less than three months later the Mail was putting the boot into Liz Truss and gloating over her imminent demise as Prime Minister. The Daily Mail and Express are the most notorious in this respect, with The Sun not far behind, but just because a paper is folio rather than tabloid don't think it is unbiased, it's just more subtle.

The Times was openly supporting Rishi Sunak and the Telegraph Truss. Significantly they both joined in with the Mail, Sun and others in running a succession of negative stories about Penny Mordaunt who had been ahead of Truss in the ballots, thus opening the door for Truss to face Sunak in the final ballot.

Not that I wanted any of them to win, and I'll be covering this in more detail later, but for now it's enough to know that the press are arch manipulators of public opinion. Not necessarily of huge swathes of the country anymore, but enough, and in the right demographic of older Tories who instinctively know where the nearest ballot box is and visit it at every opportunity, to make their influence significant.

I've come to think of the daily papers as wounded and dying animals, lashing out with increasing desperation and viciousness. Part of me revels in their myopic hate filled 'little Engerland' worldview, knowing it's their swansong, albeit racist swans with sharp teeth and a penchant for hyperbole and puns, but a swan singing its death song none the less.

The issue they face is that they can't monetise the mundane. The more lurid and frightening they can make a headline the more people buy into it and thus satisfy their advertisers, whom they have come to rely upon. Its click-bait in crinkly printed format.

It's a thought often repeated but worth restating here: the Nazis didn't get to power in the 1930s overnight. The road to fascism is paved with dehumanising words and deeds, gradually wearing down and syphoning off people considered of 'less value' from mainstream society. Look at the press coverage of people crossing the channel in dinghies and listen to the politicians. Even when they talk about support and help for what they term 'genuine refugees' the language is hostile.

And they are winning. The press and politicians have persuaded great swathes of working people that their enemies are people fleeing from the consequences of arms dealers and our government's overseas policy. It's even more objectionable when far right parties and organisations get involved but at least then you know the enemy is a full-time fascist nincompoop and needs re-educating or a good wallop.

We need to win back the hearts and minds of working people who've been duped into thinking the problem is on the beaches of Dover and not the subsidised bars in Westminster.

We live in a complicated and multi-faceted society; our everyday existence is spent weaving a path between competing ideals. The inevitable consequence is that we are all hypocrites to a lesser or greater degree. Red lines like racism and homophobia are easy for most of us but I imagine we all have social media feeds, and we tune in to television and radio that either broadly accords with our world view or, in the case of social media, is filtered to become an echo chamber of our thought and opinion.

A daily paper is the same, it's a friend to the right-wing suburbanite and the working person struggling with austerity measures - presented with a long line of brown people in dinghies to blame. The daily papers may be dying but in their death throes they are still doing damage.

While I've been rattling on about the printed media, you may well have been wondering about television, radio, and the internet. Quite correctly too, but my main objection is the partisan press in cahoots with the Conservative government's increasingly right-wing agenda.

The BBC, gawd bless old Auntie Beeb, is a state sponsored service, and as such treated with much suspicion by the right and left and generally regarded as acceptable by the middle ground. I confess to being rather attached to it as an institution, and to place it into the world of advertisers and non-domicile owners like some other channels and most of the printed media would be, in my opinion, wrong.

In a world with streaming and umpteen channels to choose from I'm not overly concerned about television or radio. Output will always be predicated by time and space, whether its column inches or news reporting and that is reality rearing its ugly head. There are plenty of radical and anarchist flavoured books, podcasts, websites, magazines and suchlike as an alternative to mainstream reportage, the trick is to get people to access them without resorting to the inflammatory tactics favoured by the mainstream press.

We need to be discerning, which you are of course, but as importantly, we need to find ways to challenge the mainstream without patronising or alienating people. That's the challenge.

At the very least we can stand up and be counted when its necessary to do so.

"There may be times when we are powerless to prevent injustice, but there must never be a time when we fail to protest."

Elie Wiesel
Nobel Peace Prize Lecture 1968

Protest

"A strong complaint expressing disagreement, disapproval, or opposition."

In the early 80s I was a young proto-anarchist and card-carrying Campaign for Nuclear Disarmament (CND) activist. In truth I was an anarchist in the sense that I believed I looked devilishly good in black, and activist meant being the membership secretary for our local, rather twee, branch of CND.

Nevertheless, to put my mouth, or at least feet, where my money was, I attended a few marches and carried placards. On one march through the streets of Ipswich we ended at a rally and 'mass die-in' where we were all supposed to sprawl on the ground as if the county town of Suffolk had just been hit by a nuclear strike.

I, anarchist to the core (ahem!) remained standing as I watched my comrades surreptitiously sweep their little spot of ground with their shoes prior to simulated nuclear annihilation. It looked to me like a very well targeted bomb had wiped out a good portion of Suffolk's middle classes. To my delight several of my teachers seemed to feature among the casualties. Disappointingly they soon rose zombie like from their make-believe demise and we all had tea and cake and were home in time for Countdown.

It looked like, and was, a very silly protest. The sort of shallow and pointless act that deserved the patronising write up it got in the local press. It achieved nothing except to make a few of us think long and hard about the effectiveness of mainstream, state sanctioned protest.

Later I went on a couple of demonstrations through the streets of London. On these occasions small breakaway groups took themselves into the commercial areas of the city and caused slight inconvenience to the temples of capitalism by breaking some windows and spraying graffiti.

It was a minor disturbance that caused no injury except for that inflicted by the powers of law and order to protect plate glass. Predictably the TV news and morning papers were awash with indignation and calls for retribution, martial law and the return of national service. I suspect the only reason the reintroduction of capital punishment for graffiti wasn't proposed was the inability of the Sun headline writer to find anything to rhyme with Death Penalty in time for the print deadline.

I've been on the periphery of a few such events since then, never actively involved because I've never been that connected to be engaged in the organisation of such a kerfuffle. Unlike the mass middle-class die-in in sunny Suffolk these disturbances grabbed attention. Much like those of Extinction Rebellion and Just Stop Oil more recently.

When a road or two is blocked for half an hour or someone daubs a circled A on the window of John Lewis the press really gets their underwear in a twist. But should the sanctimonious indignation of middle England and the occasional West End landlord really trouble us?

The people who pay attention, who see the news coverage about protests they'd otherwise never have heard of, might be critical of the methods but some will have enough zing about them to read up on the causes a bit more.

They may end up diluting the sludge of local politics with a bit of concern for the environment or find a copy of the anarchist newsletter Freedom online. Whatever, the effect of direct action is to grab headlines and start people down the road of thinking critically, thinking for themselves.

It doesn't matter how they find out, it's knowing that there is an alternative position out there and that maybe it is worth a bit of a peep behind the curtain of 'official' news channels, their flunkies in the print media and the clickbait swamp of online news.

I'm all for a softer, engage-them-in-conversations and-make-them-question-their-worldview approach. Frankly though that'll never gain the traction of a few headline grabbing protests.

Better to be ready to use polite dialogue after the headlines to challenge people in the workplace, pubs, next to you at the concert or on the football terraces. Chat about it, about why stopping traffic for 20 minutes was necessary to divert the news away from the royal family and union bashing.

A core feature of any grass-roots organisation, like those mentioned previously, and ANTIFA, Black Lives Matter (BLM) and Hunt Saboteurs among others, is that, like anarchists, they may be networked but they don't follow a universal worldview and haven't joined a club with rules and regulations to abide by.

This loose cell structure is a bugger for the authorities to deal with and more so it seems the press, who desperately try and find, or invent, a manifesto to pour their vitriol on. It's the binary worldview that they use to keep us ill-informed and in 'our place'. It was easy for them to despise Jeremy Corbyn because he was a self-identifying Socialist leader of the Labour Party. Less easy is a disparate group of like-minded people scattered around the country, around the world even.

None of which stops them portraying BLM or ANTIFA as Marxist organisations with specific agendas that ultimately would lead to the overthrow of civilisation as we know it. And in some ways, they are not wrong. Removing fascism and racism from society would be a radical step forward, but I suspect the objections of these commentators is more to do with the idea that standing up to the states' institutional racism just isn't the done thing.

A few activists don't change the world. In fact, they can be counter-productive when the response is to blow their actions up into a threat of global proportions, when in reality it was a few well-intentioned people venting their frustration and political impotence against an unfeeling state. We need to find some common ground with the people who instinctively follow the rules but haven't the generations deep pedigree invested in the system to be threatened too much by it changing.

During 2022, hidden from most eyes by the turmoil of Johnson's partying, followed by the financial shenanigans of the Truss regime, a new Policing Act, the *Police, Crime, Sentencing and Courts Act* dribbled into force in the UK.

Among its stipulations are provisions for the police to intercede for *'serious disruption to the life of the community'*, noise triggers by protesters and restricting static demonstrations. On top of these, ministers can change definitions unilaterally to suit their own ends.

Without a doubt, Black Lives Matter demonstrations, Extinction Rebellion, Just Stop Oil, and similar protests in the 2020s have triggered this government to respond with typical over-the-topness, protecting the Daily Mail reading classes who might be mildly inconvenienced, or more accurately, are extremely unlikely to be affected at all but saw some grubby students on the 6 o'clock news holding up traffic and decided to get incensed.

Penalties for all Police or Government defined breeches of the above, and more besides, are harsher than they were. This really is a clampdown on your right to protest. It's an infringement on civil liberty by a state who feel emboldened by a vacuous government seemingly impervious to criticism and unthreatened by any serious opposition in Parliament.

But what are the answers to the merry-go-round of left/right politics if protesting isn't enough?

I just don't know...

"Progress is impossible without change, and those who cannot change their minds cannot change anything."

George Bernard Shaw
Everybody's political what's what.
Dodd, Mead.

I Don't Know

"A person who disclaims knowledge, especially one who is undecided when replying to an opinion poll or questionnaire."

I was following an online debate about the rights of Trans people recently. I automatically felt myself siding with an oppressed and often ignored community fighting for recognition and equal status. Quite a few people were vociferous in their opposition to them for one reason or another.

The point that I found interesting was that the debate seemed to be mostly from uninformed parties whose lives, from all the evidence that I could gather, were completely unaffected by the community they expressed such strong opinions about.

In other words, a load of hot air was being wasted by people whose point of view wasn't encumbered by facts or lived experience. Sure, we can all hold opinions and ideas, but they are no more valid than those of a fridge if they aren't backed up by something more than *'because I think so.'*

What's wrong with saying *'I don't know'* or *'this is a subject about which I have no knowledge. Please educate me...'*? Changing one's opinion in the face of facts is a sign of maturity. It is a precious and much respected foundation of science, and by extension, medicine. Sure a few scientists cling to theories that have been disproven, ex-doctor Andrew Wakefield leaps to mind, but most accept and adopt a robust approach to their craft based on challenge.

There's nothing wrong with challenging views or having your position questioned. Most of us are culturally sensitive enough to use a modicum of tact and diplomacy. At least we are face to face. Something about social media and on-line newspaper comments brings out the bravery of anonymity.

I'm using the term bravery there, but what I really mean is stupid pig ignorant guileless trolls who infest the virtual world with their unhinged, unchallenged and mostly pointless worldview.

There's an inadequacy at the root of a lot of the strident, ill-thought-out opinions that infest social media. In our sprawling world, with technology advancing quicker than a lot of online commentators can get to the lavatory, people can feel powerless and without a voice. Chuck in an electoral system that is as predictable as it is pointless and sprinkle a dose of futile dead-end jobs and lack of opportunities for the young and old, wanton disregard for working people by the Westminster bubble, and what you have is a national reservoir of disaffected, bored and bitter people with access to the internet.

Will it ever change?

We're back to the binary again. Youth are feckless, ex service personnel are all heroes, nurses are angels, lefties are bonkers communists and righties are good with the economy, the King is wonderful, God is on our side and never shall one stray from the path.

It's all nonsense of course. So long as we're conditioned to think along rails then we perpetuate the fiction that a binary world is accepted wisdom.

I would add that in a complex world, and I speak as one who finds it increasingly difficult to add seasoning to my lunch from over-engineered salt and pepper 'distribution systems', thinking along rails is simpler and much less demanding. I get that.

The world becomes a scary place when you are fed a diet of anti-migration rhetoric, talk of an 'invasion' of refugees, crime, and disorder and all the other juicy nonsense our press and media love to titillate us with in their increasingly desperate circulation wars.

But we can make a difference. We need to admit that we don't know everything and be prepared to listen. Challenging the state may be a delightful pastime but its futile without popular opinion on our side, and that, my friends, is where we need to begin.

Somewhere our society has moved away from companionship and discussion. We entrench our positions and lack the opportunity to discuss, and I can't stress this enough, to LISTEN to other points of view. Not just hear them but listen and consider. That's where a more nuanced approach to politics, indeed to life, is so important.

I'm not pretending that dogmatism will evaporate into the ether, but we can grasp some of the middle ground from the closeted world of middle England conservatism (small c deliberate) engage working people in discussion away from the shouty echo chamber of social media and challenge people to think critically about the diet of extremism we are spoon fed by the press.

I don't know the answers; and that's kind of the point. The quest for a definitive solution to all of the problems in our world is pointless.

They're too big, too many, and anyway people have a habit of being, well, people, with all the contradictions and frustrations inherent in the human species. Better to start eroding the edges of our carefully constructed state, blunting the extremists and irrational traditionalists and turn our focus away from the privileged and start looking at the pillars that keep them aloft.

Where better to begin then than the middle?

Let us take a wander down the well-kept avenues of suburbia, past the freshly washed cars in the driveways and peek behind the Dunelm curtains and meet the middle classes of England on their home turf.

"Our inequality materializes our upper class, vulgarizes our middle class, brutalizes our lower class."

Matthew Arnold
Complete Poetical Works of Matthew Arnold
Delphi Classics

The Middle Class

"A social group that consists of well-educated people, such as doctors, lawyers, and teachers, who have good jobs and are not poor, but are not very rich."

I am middle class.

There, I said it. It's out in the open now. The road to recovery may be long and arduous but I've taken the first step.

It wasn't that hard to write it out, but it took me a few years to admit it, first to myself then to others. That was even though I grew up in suburban Hertfordshire, then a leafy Suffolk market town, had parents who were home owning aspirational professionals, albeit from working class London stock, and have, frankly, lived a safe Anglo-Saxon middle class existence since the age of zero.

Class isn't important.

Except it is. It really is. It defines us to ourselves but more importantly it defines us to others. It becomes an identity that we can hide behind, celebrate, or use to bully and patronise others. It's a set of ever-moving goalposts that can be a blessing or a curse.

It is the key to our opportunities and aspirations, whether we grow up on an urban estate or a country estate. It can open doors or slam them in our face.

I'd love to live in a classless society. I tried it for a while. Well, what I really tried was to pretend that class didn't exist, or at least that it wasn't important. It was during Margaret Thatcher's reign, when her warped ideology ransacked the nation, destroyed communities and she sold off our national assets. It was probably more an extension of my middle-class guilt because clearly what her government did was to amplify and exploit class divisions.

Since then, we've had a succession of Conservative and Labour governments (Labour was of course rebranded New Labour under war mongering old Etonian Tony Blair) and for a brief spell we had the Liberal Democrats in coalition with the Torys, who were like an elderly spouse reigning in their other half's inappropriate behaviour while they're out together in public.

Meanwhile the middle classes of Britain continue to hold sway on election day, voting blue for tax cuts or red for what their mistaken liberal views confuse as redistributing wealth, depending upon how much loose change they have squirreled away down the back of the Scandinavian sofa that month.

Although definitions vary and surveys are open to question, the middle classes of Britain make up over 50% of our population, and nearer to 60% according to some sources. That's a large body of people with the right to vote and to exert pressure in the right (or wrong) places.

It would ill befit my stance on a non-binary world of nuance to try and characterise every member of our middle classes as a Daily Mail reading white Christian monarchist. Many are decent people who want a better world for everyone and wouldn't dream of torpedoing ships carrying refuges over the channel.

One of the defining moments of the 2020 general election was the breaking of the so-called red wall, when Conservatives were elected to traditionally working-class Labour seats. In the previous elections the odious UKIP had preyed on these voters. Both examples illustrate how safe and liberally middle class the Labour party has become. Out of touch with its traditional voters and too self-obsessed and media conscious to seriously challenge the narrative of suspicion over immigration and the so called 'woke' snowflake generation peddled by the popular press and their Tory backers.

Ultimately none of us can help how we're brought up. Until our teens we are mostly powerless and even then, we may well be conditioned into thinking inside carefully imposed parameters, by schooling, parents and peers.

The products of expensive private education can't help their fate. They were probably signed up to attend a school where you're encouraged to bring your own pony long before they were a twinkle in paters monocle. One day they are released from Latin prep and rugger and gravitate to a university founded before Gutenberg started printing bibles and thence into a life of open doors and closed minds.

Now, a word of caution here. Private education does not necessarily turn out bumbling chinless Tories. Indeed, many people who have made a positive difference in the worlds of science, the arts and occasionally politics, come from privileged schooling and the sort of universities where royalty once stalked the cloisters.

Nevertheless, elite education isn't generally the preserve of everyone. Occasionally scholarships do permit someone showing academic promise the opportunity to be sneered at by their fee-paying peers. But they are exceptions rather than the rule and anyway rely on the parents wanting to send their precious tykes off to a world where the uniform specifies breeches. You kind of suspect they already aspire to being part of that clan, so the chances of them rocking the boat are slim.

Whatever your thoughts on private education, class barriers can be crossed in all directions. We need to challenge a culture of anti-intellectualism as much as anti-working class. It's not realistic to expect a totally classless society.

However, when you're already being squeezed into a system that prioritises exam success over education and conditioned into a way of thinking that suits the election chances of the government over progress, then you are essentially a product for them to manipulate. What's lacking, whether you're from fee paying or comprehensive schooling, is the ability to think critically about society and universal values outside of the path of least resistance. Teachers are restrained by bogus targets and curriculum that shackle them to the government's agenda irrespective of their individual abilities and experience.

I would very much like my family doctor to be educated to a high standard. It would be nice if they have come from a terraced house in Hull with a staunchly working-class background and have been afforded a proper education regardless. It can, and does, happen of course but according to The Sutton Trust 61% were educated at independent schools, nearly one-quarter at grammar schools (22%) and the remainder (16%) at comprehensives.

Only 7% of our precious young tykes are educated at private schools.

Education reform is a huge topic. Looking at the pace that the world is developing, the knowledge our young people need is ever expanding and far too vast for a traditional curriculum. Far better to teach the skills of research, critical thinking, reasoning, the arts, music and the life enriching skills and knowledge one needs to navigate the bumpy path of adulthood, along with numeracy and literacy of course.

It's therefore rather grating to find the Conservative government constantly repealing creative courses and harking back to the 'good old days' when the academically inclined were cherished and nurtured and the rest of us fell from the learning tree like rotting fruit. Handy for them as we could then do their menial tasks while they blossomed into lives crammed with expensive fripperies.

A quick look at the Conservative Party website's section on education (as I did; now to wipe the cookies clean and burn my hard drive) and you'll see an emphasis on behaviour and 'standards'. Standards is a rather nebulous concept that's only measurable once you invent the standard to judge by.

As for behaviour, unruly or disruptive behaviour in school is a problem, but it doesn't manifest out of thin air.

It is often a symptom of a wider underclass of people taught that they have limited or zero prospects because of the crushing poverty, lack of respect and lack of opportunities given by the state, which frequently runs through successive generations. Tackle the inequalities and resource education properly and not as a filtration system to weed out the working class, and maybe we'll make some progress.

Through a close acquaintance I had contact with a school in Stoke. It was in one of the poorest neighbourhoods in the UK. Hard work for everyone, including teachers who were judged on the academic attainment of the pupils.

A rule imposed on the staff was no visible tattoos or piercings except one ear stud per ear. The subtext being that piercings and tattoos are not things nice middle-class people have so you'll not see them among our teachers. But maybe being taught by people you can identify with, diverse and reflective of your world is desirable?

Apparently not. As soon as those pupils walked into school, they were confronted with a display of the class system at work, conditioned into believing that success and a career like teaching, or as a member of the ancillary staff team, equated to undecorated skin, no piercings except the state sanctioned ones and the hair colour provided by mother nature.

Become a middle-class white-collar drone and slave away in the underbelly of the beast for your betters. But fear not for you are living in a democracy and so your fate is in your hands...

As if...

"Democracy is a con game. It's a word invented to placate people to make them accept a given institution. All institutions sing, 'We are free.' The minute you hear 'freedom' and 'democracy', watch out... because in a truly free nation, no one has to tell you you're free."

Jacque Fresco
Original source unclear, retrieved from The Anatomy of Wake-Up Calls Volume 2: Psychology of Survival by Dr. Feridoun Shawn Shahmoradian

Democracy

"The belief in freedom and equality between people, or a system of government based on this belief, in which power is either held by elected representatives or directly by the people themselves."

I had him pegged as a Daily Express reading caravan owner, from his garden centre leisurewear to his shoes chosen for comfort. He ambled into the café and took a seat while his wife perused the menu with the keen eye of one accustomed to scrutinising entrants in the 'best display of vegetables' tent at the church fete. I half expected her to grab a pen and correct a rogue apostrophe.

They seemed gentle and kindly souls, based on my brief encounter anyway. They certainly didn't seem the sort of people to winkle out the cobblestones and smash the shackles of oppression, at least not without the promise of a nice cup of tea and slice of Victoria sponge afterwards.

I imagined them in a house barricaded from the world by a neat herbaceous border and manicured lawn. Middle England incarnate gliding towards the time of life where they get more invites to funerals than weddings.

This is the generation that holds sway over our lives, they exercise far more power than they realise and could comfortably handle, if only they knew. These are the voters, often for any old stuffed sack of tweed wearing a blue rosette.

Some of the more enlightened may venture a dalliance with an orangey yellow, green, or even red if the mood takes them, although they wouldn't dare to admit it over instant coffee and Lidl digestives at the neighbourhood watch meeting.

The young woman bringing their drinks reads the Guardian and voted Labour. They promised to get rid of her student loan and she felt that they were generally reasonable people. They'd improve her broadband, raise the minimum wage, plant more trees, and probably wouldn't declare war this time around.

Life is a struggle for her at times. Rent for a room isn't cheap but living with mum and dad means moving away from the social networks she made through university. There's little hope of finding accommodation with the council. They have precious few homes left since the bulk of their stock was sold off. As a single person with an income and the safety net of mum and dad she can't get on a housing association list, and if she did, the chances of getting allocated anything are slim to none.

Her employers are good, but working in a small café isn't a career that'll pay to get her out of a single room. She thought her degree might open some doors but then so did 50% of the people around her age working in the shops and businesses around here. She remembers her grandfather's house. A council semi in a time when you were all but guaranteed housing if you were local. Families lived close by each other, and a young person could start with a flat and aspire to a house in time. It wasn't perfect, but there was a logic to it and a sense of belonging to a community.

Most importantly for her grandfather, she recalled the sense of pride he had in being a council tenant. In his day they weren't demonised in the papers and only for the 'deserving poor', as the local Conservative Mayor said in the local rag.

The estate where he'd lived is mostly privately owned now. Houses sold for ridiculous sums to private landlords or families wanting a sturdy home close to work. The only council properties were some sad little bungalows with grab rails in the bathroom and hastily built ramps to the front doors.

The couple just leaving with their reusable cups in a Greenpeace tote bag voted Liberal Democrat because they didn't like the other candidates. The Tories were too right wing but Labour too radical. They didn't want a repeat of the bus strikes of '98 when it took him 20 minutes longer to get to work one Thursday.

They like to 'do their bit' for the planet. Recycle obsessively, drive a hybrid car and volunteer with neighbourhood watch, the local horticultural society, and at the local library where she reads to children while he helps out at the foodbank. They both see an increase in people needing help, people visit the library for warmth and someone to talk to.

More elderly people come into the foodbank, he watches them standing over the road from the church hall, waiting until they think no one will see them. He sends them home with their goods in supermarket bags so they look as if they've just been to Asda rather than accepted charity.

He sees more young families coming in now too, and people who have jobs that manage to pay the minimum wage yet still leave people poor. Carers who must pay their own petrol costs for driving between visits, fast food servers on zero hours contracts, people who are trying to service mortgages and debts as prices rise and wages remain static. Popping into the café is a treat they allow themselves once a week after doing their bit.

Everyone in the café believes in 'democracy'. Our Express couple, Guardian woman, and tote bag duo. The opportunity to vote in a first past the post system based on the principle that the winner with 51% gets to choose and the other 49% can lump it. Well, fair enough that's how it has always been done, and if you happen to have placed your X in the losing side's box, well, that's democracy for you.

So, they accept it. Mr and Mrs Conservative and Ms Labour and even the Totes, although they'd quite like proportional representation so long as extremists don't get in by the back door.

To the delight of the ruling classes, we just accept that losing an election is fine and dandy and shows that we're a mature nation who accepts defeat as a natural consequence of democracy.

But that democracy is built on an illusion.

In 2019, when most of the present crop of our elected representatives was given the key to the members only bar in parliament, 29% were privately schooled, a figure four times higher than their constituents. Only 41% of Conservative MPs and 70% of Labour MPs were from comprehensive schools.

Away from parliament, other key positions of influence are dominated by the privileged; 65% of senior judges, 59% of Permanent Secretaries, 44% of newspaper columnists along with 49% of the Armed Forces went to fee paying schools, so I think we can guess where their loyalties will lie if insurrection ever threatens. The numbers that went through Oxbridge are even higher, with senior judges rising to 71% for example.

You don't have to have attended private school and then an ivy clad university to be a member of the ruling elite, but the chances of you ever being anything more than a token working class figurehead wheeled out to reassure the electorate that people with regional accents can wield power are slim to none.

Our parliament is a compass that always points due breeding, whoever sits in the big chair.

Behind the scenes, and away from scrutiny, are the banks.[4] The banks tether us to the system that controls us. Mortgages and loans mean that we are invested in the system. Try living without a bank account, it's nigh on impossible. Add on tax, rent, driving licences and so on and you come to realise that we are, consciously or not, cogs in the enormous industry of state.

Living outside that state isn't practical and some state-controlled mechanisms are of benefit. The NHS is a good example. Flawed, bloated, inconsistent and grossly underfunded, but nevertheless a service we need and should value.

All of which, by a somewhat circuitous route, brings us towards the point.

[4] Don't worry, this isn't going to turn into a tirade about the illuminati.

Our democracy is a sham, a fiction designed to keep the same people in power. It's deeply flawed and corrupt, a point that has remained unchanged for centuries, but underlined by the lying sack of tousle-haired custard who masqueraded as Prime Minister until he was usurped by another lying sack of custard with better hair, and then another one with immaculate hair. The spineless whelks sitting opposite them in parliament are little better. Yet we trundle along believing that a legislature of groomed elite, propped up and enforced by their chums in the courts and press, is our best option.

Mr and Mrs Tory from the café, Ms Labour who served them, and the Totes buy into the fiction. They might admit that the system isn't perfect, but the alternatives they are presented with are just different types of the same rancid fruit.

Calling for revolution won't appeal to our Café dwellers. They've too much invested in a system that enslaves them from primary education through to nursing home. A system that they defend. It's a sorry situation when we are regulating ourselves on behalf of the state but that's what happens.

Somehow, we need to dismantle structures built over centuries while simultaneously retaining the elements that serve us. Again, I'll choose the NHS, albeit in a vastly amended and improved state, as my example here.

Get them talking and away from the binary world of only two parties that are ever likely to form a government and we'll find common ground.

Most people want peace, security, health care and a roof over their heads, it's not a question of left or right, but a distrust of politicians, national and local, and a feeling of powerlessness in the grand empire of our state institutions. Seeds can be planted without resorting to discussions on the merits of Anarchism without Adjectives over Individualist, Marxist or Collectivist schools of thought.

One other part of the conundrum we haven't tackled yet is the House of Lords. This is the second chamber of our parliament and supposed to be independent from it. That is, if you accept an unelected body of the 'great and the good' who often sit on party affiliated benches and are there because they've proved some service to the institution of state as being independent. At least in the lower chamber there is a pretence at democracy.

There are cross bench Lords who straddle the non-party associated benches. They may be officially nonpartisan, but you can bet they're not sitting there because they were a dinner lady from Coventry.

Around 25 Bishops of the Church of England sit in the Lords too, because state religion must be at the seat of power. This of course makes no allowance for other religions, atheists or for sake of argument, vegetarians, who may not be a religious group, but they make up around 10% of the UK population, that's 6,700,000 people, unlike members of the Conservative party who boast around 173,000 members or 0.00030% of the population[5].

[5] Approximately. I'll let you do the sums for yourself, let me know if I'm wrong.

At the time of writing, there are 257 Conservative sitting members in the House of Lords, 186 crossbench, 166 Labour, 83 Lib Dem and a smattering of others make up the rest, along with those Bishops there to put forward the Christian position in our unelected upper house. Roll up, roll up, come see democracy in action folks.

If revolution isn't an option, and considering the government's record, if that hasn't brought people onto the streets nothing will, then how do we convince our café people that there is an alternative?

There are of course several alternatives, but part of the issue we face is that our press, and to some extent education, has conditioned us to think in binary; which of the two options do we choose? Life, once you've stopped reading books with primary-coloured pictures bigger than the words, is a complex multi-layered experience crammed full of nuance and seldom ever black or white, yes or no, good or bad, etcetera.

It's an issue I'll be tackling next.

"*The fear of freedom is strong in us. We call it chaos or anarchy, and the words are threatening. We live in a true chaos of contradicting authorities, an age of conformism without community, of proximity without communication. We could only fear chaos if we imagined that it was unknown to us, but in fact we know it very well.*"

Germaine Greer
The Female Eunuch

Binary

"Relating to or consisting of two things, in which everything is either one thing or the other."

Before we delve into this chapter, I want to make the point that I'm using Brexit as an example. As so much rode on a win or lose vote, I feel it's a good illustration. One's views on whether it was right or wrong are, at this juncture, less important than the process.

Let me explain...

Imagine a role-playing game where the protagonists get to choose their fate by the roll of dice. There are plenty of these around, from Monopoly to Dungeons and Dragons.

Games like this are often complex and require strategy as well as luck. You roll one or more dice to try and advance and fight all manner of foes along the way. At a basic level we're talking two traditional 6-sided dice. So that is 36 possible combinations.

For more advanced games there are multi-sided dice that introduce many more combinations, so strategy, luck and a healthy dose of experience all combine to make up a successful campaign.

What grown-up role-playing aficionados understand is that the fantasy world that they immerse themselves in is complex. It's a world with competing priorities and rapidly changing scenarios, where the unexpected can change the course of events and make or break a game.

One weighs up competing pressures and resources to find the best solution to an obstacle. The random element introduced by the die is an added tension in an already complex scenario. Players must be ready to adapt, change their strategy, maybe make a strategic withdrawal, or make the best out of an unplanned hazard.

In the big wide world outside of the role-playing gamers' universe we face similar situations daily. Few decisions that we take lead to a 100% good or bad outcome, except maybe ones like *'shall I step off this cliff into the barrel of boiling acid with my testicles tied to a stake, or not?'*[6]

Which makes our decision to base Brexit on a solitary Yes or No vote so appalling. I'm going to assume that if you voted for it, or declined to vote at all, you will be disagreeing with me now. That's fine and dandy; well done you. Everyone has their reasons, and I trust that yours were more complex than the *'I want my country back'* drivel we heard at the time.

Did many voters research anything beyond what they read on social media or the side of a bus? Did people *really* believe the NHS would benefit from Brexit? Did they think it would stop immigration or that we'd have proper bendy bananas instead of straight Euro ones?

Did people believe our sovereignty was threatened or that we would be using the Euro to pay for our French wine and German sausages from now on?

[6] Probably best not.

Did anyone believe the lies and manipulation of a press and pro-Brexit lobby who did their utmost to pretend that we'd be able to re-set the clock to some mythical 1950s utopia before hippies and foreigners 'ruined' the country?

Did they think that if something unexpected came along to upset their utopian red, white and blue wet dream, we'd just forge ahead, because mindless optimism and bulldog spirit will always win over cold, hard facts? Something like, oh, I don't know, a global pandemic.

Yup.

Put a blond buffoon in charge, repeat the same tired phrases and carry on regardless.

People may have voted for Brexit, but no one in power seriously gave a flying squirrel what you thought. We've been played.

I'm choosing Brexit here as it's the perfect example of a complex argument diluted to a binary decision. Ridiculous maybe, but there you go. It's like choosing your favourite potato. You must decide what you want it for before you can make an informed decision; crisps, mashed, chipped, baked, to shove up Jacob Reece-Moggs gusset? They all have different qualities and attributes, and each has its advantages and drawbacks.

Brexit was the same. I don't want to live in a European superstate, but I do feel more affinity with the working people of France and Italy than Westminster, or Holyrood, as I reside in Scotland which is a country that overwhelmingly voted to remain but is now lumbered with the decision anyway because a swathe of England believed the hype.

The same sad little pantomime gets played out at every election. In most constituencies you get at least three stooges standing and, realistically, the choice of two who could win. In some areas you could put a blue or red rosette on a fence post and get it elected. In truth it'd probably do as good a job as some of the lumps who litter the benches of the House of Commons, whose biggest challenge is whether to wear their regimental or old school tie.

One of the more frustrating elements of our election process is the propensity towards thinking we are electing a prime minister rather than our local constituency MP. The press gleefully demolishes the party leader they dislike and promotes the one that'll serve them best when they sit in the big chair, giving the newspaper owners who got them elected a prime seat at the table when it's time to dish out the gongs.

It's all a bit of a farce. An illusion of democracy taken to the level where the ability to place an X inside a box, a skill generally mastered by the time you move up from the reception class at school, is the main qualification. Not that I am advocating for wholesale revolution.

Well, I am really but I recognise that won't happen any time soon. We could start with political education though. Not from a party politics line but about how the system works, from local council to Westminster or Holyrood or wherever. It's not just important, it's vital if we are going to be accountable and work towards individual responsibility, taking account of our own actions, dismantling all but the most vital institutions of state, abolishing hereditary privilege, reversing the patriarchy and generally being nice.

I know that there are a million and one reasons why you may take issue with this, but flawed though the system is, what really lets us down is us. It's our lack of political insight and understanding, our lazy approach to fact checking and reliance on social media or the newspapers for our information; for voting the same way as our parents or because we'll get tuppence a month off our mortgage or pay a penny less VAT on Italian cheese graters instead of universal healthcare if we vote a particular way. Not you obviously, but every other citizen of planet Earth.

We are, by and large, hypocrites. Maybe we try not to be, but it is hard to tread a line sometimes. White lies, omissions to spare feelings, telling a five-year-old that their lump of macaroni and glitter is wonderful and sticking it on the fridge, that sort of thing. We all do it. Like the Christians who believe in the death penalty or the *'All Lives Matter'* brigade who don't include migrants, refugees, or people with a darker skin shade than them in that sentiment.[7]

Not forgetting the *'I want equality, justice, affordable housing, an NHS that is funded and fit for purpose, jobs for young and old, decent pensions, inexpensive public transport, decent education and peace on earth'* people who for some obscure reason think this wish list will be fulfilled by voting Conservative.

How does that stack up?

[7] If you are not familiar with 'All Lives Matter' or its equally idiotic cousin 'White Lives Matter', they are a reaction to Black Lives Matter and essentially the preserve of ignorant white people and fringe far right political parties who feel persecuted and ignored because for a few minutes they aren't the centre of the world.

How does someone whose politics is based on greed and competition arrive at the conclusion that the party for them will also deliver all those things I mentioned, and more besides?

We're back to that binary dilemma again. Rich or poor. Create wealth or distribute it. If you create it maybe some of it will run between the bloated fingers of corporations and the captains of industry and fall like holy water on the impoverished, so that they can afford a mortgage and be in hock to the bank for the next 25 years, invested in the system that is robbing them of their rights, money and dignity.

I don't know the answers, but I can say with some confidence that educating people on how our state works would be a good starting point. Maybe then people will see through the illusion of first past the post being anything other than a competition that can leave over half the electorate disenfranchised and the winners smugly doing as they please with no popular mandate.

Proportional representation is often derided as the route to stasis, but it would at least be representative and maybe rather than having MPs divided between the colour of their rosette they would vote independently according to their conscience and their constituents' best interests. It's the way the devolved nations of the United Kingdom work. Marginally better than Westminster, although as I write Northern Ireland is politically gridlocked.

I know it's not a traditional radical view, and a proper, working people led revolution would be better, but the reality is that on the odd occasion it's been tried it hasn't ended well. The ruling classes have too much invested to let it slip away because of a few well aimed cobblestones and a bit of a ruck down Whitehall. Educate and infiltrate their election process, educate from the platform and the tide might start to turn.

Party politics should be dead and buried except to share resources. Teach people how our system works and perhaps they'll come to realise how it's flawed and working against them. As was once said by a leader desperate to attract the vote of the child-bearing aged electorate, *'education, education, education.'*

Education that is warts and all. Comprehensive, honest about our past, diverse and free of all the quasi-imperialist nonsense like enforced worship, flag waving and singing the national anthem.

Speaking of which...

God Save the King

God save our gracious King,
Long live our noble King,
God save the King!
Send him victorious,
Happy and glorious,
Long to reign over us,
God save the King !

O Lord our God arise,
Scatter our enemies,
And make them fall!
Confound their politics,
Frustrate their knavish tricks,
On Thee our hopes we fix,
God save us all!

Not in this land alone,
But be God's mercies known,
From shore to shore!
Lord make the nations see,
That men should brothers be,
And form one family,
The wide world ov'er

From every latent foe,
From the assassins blow,
God save the King!
O'er his thine arm extend,
For Britain's sake defend,
Our Father, prince, and friend,
God save the King!

Thy choicest gifts in store,
On him be pleased to pour,
Long may he reign!
May he defend our laws,
And ever give us cause,
To sing with heart and voice,
God save the King!

Lord grant that Marshal Wade
May by thy mighty aid
Victory bring.
May he sedition hush,
And like a torrent rush,
Rebellious Scots to crush.
God save the King!

Monarchy

"The system of having a king or queen."

When I started writing this chapter, we had a Queen who had just celebrated 75 years of waving and being the face of our currency, and the longest queues in London were for a Greggs vegan sausage roll.

Then Liz Truss galloped up to Balmoral after winning the most absurd leadership election imaginable, and Her Majesty took one look at her and popped her clogs. Most of this chapter was written before she kicked the royal bucket, but in an act of uncharacteristic benevolence I have expanded upon it by considering recent events. You can thank me later.

A while ago, in a moment of weakness, I started watching The Crown, a fictionalised history of the Royal Family from the 1930s up to modern times. Against my expectations I rather enjoyed the first couple of seasons. I learned a lot about the abdication of Edward VIII and the circumstances around it. Although it was fantasy it was based on real people and real events, and it acted as a springboard to launch me into further research about topics and people who piqued my curiosity.

As an aside, we stopped watching when it got to the Margaret Thatcher years and in an excruciating episode the iron lady from Grantham was belittled by the Royals at Balmoral. As my wife pointed out, she couldn't watch it any longer because she was beginning to feel sorry for Mrs T.

It is odd then that I feel slightly defensive about the royals and faintly guilty admitting I watched The Crown. More so that for the most part I enjoyed it, because I am not a supporter of a monarchy. To admit to being a republican in some people's minds is synonymous with being a traitor. To them, being born in a country with a monarch is enough to demand unquestioned obedience and servitude.

I didn't really dislike the Queen as a person. I mean, I hardly even knew her. She seemed like a tough old biddy and the job was thrust upon her unexpectedly. She mostly kept out of politics in public, did a rather good wave and undoubtably brought in a few tourist dollars.

Then again, she didn't reject the position or declare the whole divine right to rule and eat swans for breakfast as a travesty and choose instead to live in a semi in Kidderminster either. She didn't question the structure that placed her on a throne or the grovelling servile toads who thought she was the embodiment of the Great in Great Britain.

For a while everything in her royal rose garden was fine. She could wander around the commonwealth reigning benevolence upon the natives, the grandchildren were young enough to be locked away in leafy schools, Prince Philip was a benign nuisance, like the racist neighbour from a 1970s sitcom, Charles was little more than a lumpen piece of tweed covered furniture and Diana was the queen of hearts, Gawd bless her.

Then Di's car bounced off a Parisian underpass and every royal correspondent on the planet descended on London and poor old Queen Liz had to think fast and remember that the great unwashed were watching through their union jack binoculars and sharpening their pitchforks.

Post Diana, we are into different territory. The fruit of her loins are beloved by the Hello reading classes, or at least were, until one of them married a woman of dubious skin tone and went to live in the colonies. Andrew now has a few questions to answer, but hasn't broken into a sweat, Fergie is persona non-grata and insists on driving herself through tunnels and Anne seems happy to romp around the countryside and wear her medals to breakfast.

Trouble is, the next in line to the throne when Liz went toes up was the buffoonish twaddle-monger Charles. The patriotic, royal souvenir supplement keeping brigade did not like him, right up to the point where he became King and thence their loyalty to the crown was assured.

The right-wing press took him to task for meddling in politics, by which they mean anything vaguely political that doesn't support their editorial line. Ripping foxes to shreds good, caring for refugees bad. Plus, he seems fond of the environment, as long as it's owned by people who favour mustard coloured corduroy, generates a lucrative profit and the begonias don't answer back.

They are even more contemptuous of Camilla (the monarchist public that is, not the begonias, whose opinion on the King's Consort is unknown to me). It seems her crime is mostly that she isn't Diana. On royalist sites they emphatically did not want her to become queen.[8]

The odd thing is, she was born to it. She is upper crust old money who is as comfortable in jodhpurs mucking out the stables as she is in tiaras. She can wave and patronise locals like a pro and always pronounces the R in off, as in 'get orf my land.'

[8] Honestly, the things I read for you.

But she isn't a fairy-tale princess. She's not Diana. Or Kate. She doesn't do carefully choreographed 'hidden camera' photo ops at the gym or have her hair done before strolling across a minefield for the cameras. She doesn't post pictures on Instagram of tots learning to smile at the peasants.

When the royalists toast the royal family by supping French champagne from Irish Crystal, they seem faintly embarrassed that the King's Consort is Camilla and not their beloved Princess Di.

Except that's not what they signed up for when they bought all that Chinese union flag bunting and plastic flags made in Europe to wave every time one of their betters pops out another sprog, celebrates a jubilee or opens a hospital. If you want a royal family, you get what you are given, that's how it works.

You don't get a say. It isn't democratic and never has been. There is no popular vote, first past the post or premium rate phone-in ballot after the news to select a majority monarch. You, you gorgeous slab of proletariat humanity do not count. Never have, never will.

Not so long as they rule. Lizzy may have been relatively benign and harmless, but the monarch could wield great power if they chose to. It's kind of a shame that they don't really. Instead of being some ruddy faced ornament wheeled out to say hullo to people we want to sell guns to, Charles could reform parliament, dissolve the House of Lords and make everyone who has a tattoo of St. George or writes to The Daily Mail have a circled A tattooed on their forehead.

Without a royal family we could have a president instead. President Sunak anyone?

No, of course not. The alternative to a monarchy does not rest on a simple binary solution. We could have a mature debate and find a way to select a figure head if that's what people want. Someone good at greeting foreign heads of state and opening municipal buildings, but without the power to invade Madagascar[9] or give their children Wales as a 21st. birthday present.

If you think we'd never allow such a thing as a president elected by popular vote in this country, cast your mind back to Thursday 12 December 2019 when Johnson smarmed into number 10. He was elected on a single issue – Brexit. He refused to take part in debates and was chosen, presential style, as our PM, rather than by being the leader of a party that had the most members of parliament elected from their constituencies. We've touched on this theme elsewhere so, moving on...

It would be nice to have someone as head of state who doesn't 'rule over us' but represents us instead. Someone with a bit of pizazz but with the political clout of loft insulation. Personally, I didn't object to Lizzy seeing out her time in that role, and if Charles were to fit the bill and be prepared to reign in his reigning then he could continue.

Here isn't the place to look in detail at how that might work but essentially, I like the living link to history and the pomp sometimes. No reason to throw the blue-blooded baby out with the bathwater. I realise that I'm probably not winning much support for that view here but in a world where people needlessly die of hunger and in pointless territorial pissing conflicts around the globe, I really think we have bigger issues to solve than a bit of pageantry.

[9] I don't think the monarch really has the power to invade a foreign country, at least not without some parliamentary shenanigans first.

What I object to is the fawning servitude and holier than thou reverence placed upon the institution they represent. Every time we acknowledge it, we're placing them on a pedestal, accepting that one human being has more right to life, liberty, and respect than another.

When Liz passed away from 'old age' there followed a bizarre period of national mourning. The country spiralled into a festival of competitive mourning. Fair enough, she was a popular monarch who was respected for her public neutrality and all round regalness. It would be churlish to deny that she was important to many and her departure from this mortal coil has left some bereaved and others sad at the passing of an era.

Her death was also the symbolic end of a generation and what followed was a display of Gold Medal winning Britishness. Queuing to Olympic standard, wall to wall news coverage of every detail, d-list celebrities telling inane stories of how she once glanced in their direction, pageantry and medals to make a North Korean parade look shabby and the public shaming and threatening of anyone who questioned the institution of monarchy or what Prince Andrew may have done with his crown jewels.

If the 24 hour long, 10-mile queue to spend 20 seconds filing past a sarcophagus, or the mile and a quarter long, 45-minute procession of plumage and medals through the capital was in China, Russia or the aforementioned North Korea, they'd be ridiculed in the press for their quasi-religious devotion and the insinuation made that they were coerced.

What's sad is that in sunny ole Englandshire we coerced ourselves and shamed those who felt differently.

To halt this outrageous syphoning off of our collective self-esteem we could, oh I don't know, maybe cut the royals off from their executive powers, scale back on the funding and stop standing up when the anthem is blasted out of the orchestra pit by musicians paid less in a week than the price of the royal cummerbund holding back too many fish egg vol-au-vents.

Obviously, change isn't going to come soon, or power ceded with good grace. The right wing love their Kings and Queens because they represent a mythical age when they understood the world of milk in glass bottles, getting thrashed for having head lice and enjoying the spectacle of Mr Smith at number 73 beating his wife every Friday evening. The street didn't smell of curry, Britannia ruled the waves, and we could stick it to Johnny Foreigner and laugh at poofs on TV without some killjoy asking us to stop and think. A land where a piece of fluttering red, white and blue cloth meant white people and brown sauce.

The monarchy is intrinsically linked to this jingoistic patriotism. It does not have to be like that though. We can love our freedom to publish what we like, this, for example, without the risk of a refreshing cup of novichok tea. We can celebrate our spirit to help people fleeing violence and war, to accommodate differing views and ideals. To have a national health service and to support each other in times of need, and where all sorts of diverse subcultures and lifestyles can successfully co-exist.

It's not perfect, we've too many bigots, intolerant bottom feeders and a penchant towards moaning instead of action, but I'd lay a lot of the blame for that at the feet of the media and their readers, as well as the political classes and a broken education system. The people who revel in uniformity and freedom - so long as it is the freedom to look, think, act and worship the same as them and genuflect to the royal family out of habit rather than thought.

If we start by dismantling the mystique of the monarchy, the very embodiment of narrow minded, unquestioning patriotic zeal, we could begin to turn things around and start to bring about real, lasting political and social change. In some ways programmes like The Crown have helped. It may be fictionalised but they didn't shy away from ties to the Nazis, laddish behaviour, the sowing of extramarital wild oats, aloof snobbishness, distant and bullying parenting or treating Prime Ministers with amused contempt because they came from an obscure Lincolnshire market town.

I thought things might be turning until witnessing the spectacle of unquestioning devotion to the institution of monarchy smear itself along the banks of the river Thames and into Westminster Great Hall. Maybe we haven't outgrown our infantile subservience to our 'betters' after all. Do we prefer to be bossed around by people who own most of Cornwall and have a separate wardrobe for ermine and tiaras, rather than exercise some responsibility for our collective wellbeing?

As I write yet another revision, the press and royal watchers have got themselves into a tizzy over a book entitled Spare, by Prince Harry. From what I can tell from the press coverage it's a long bleat by someone annoyed at being put on the bench as a reserve when the crowns are being handed round. As much as I'd like to think it'll be a nail in the coffin of the monarchy, experience suggests it's as likely to harden monarchist attitudes and reinforce those of republican tendencies. At least his book stops unpleasant things like wars, illegal occupations, genocide, workers' rights across the globe, environmental catastrophes and suchlike intruding into our lives via the television or daily paper.

Progress may come if King Charles III messes it up and we see through the veneer of hereditary privilege. Failing that we must encourage him to relinquish his God given power over us, not unreasonably in my opinion, as there is no evidence to support the notion that God, if he, she or it exists, had anything to do with the decision in the first place.

"All good men are anarchists. All cultured, kindly men; all gentlemen; all just men are anarchists. Jesus was an anarchist."

Elbert Hubbard
Selected Writings of Elbert Hubbard

Religion

"The belief in and worship of a god or gods, or any such system of belief and worship:"

Imagine an alien has just landed on earth from, oh I don't know, a planet orbiting the star Canopus. Let's call it Proudhon. It's landed in a field, a big, big field and encircling its green alien arse are representatives from every one of the earths religions. That's about 10,000 people, every one there to convince you that theirs is the one true path to immortality or whatever their deity has on offer this week.

Now, our extra-terrestrial friend may be green but it isn't stupid, so it discards the kooks and obvious oddballs. Your Jedi or any of the other weirdness that students think passes for fun after a subsidised shandy in the union bar. Now the serious work begins. Does it veer towards the mystic, the sun worshippers or the stern-faced men in frocks? Does it find itself attracted to the earth mothers or the prayer wheel spinners? How to choose? Toss a coin, interview them, read the pamphlets and holy books?

Let's assume that it eventually favours the Abrahamic[10] faiths, if for no other reason than it suits my purpose.

[10] After Abraham – essentially from one spiritual source.

Now we have discarded quite a few but we're still left with Judaism, Christian, Islamic, Baha'i Faith, Yezidi, Druze, Samaritan, and Rastafari faiths, to name the most prominent ones. Our friendly but spiritually bereft alien is still confused. These make up a sizable proportion of the world's religions but with the tendency for schisms and varying interpretations they still represent a bewildering array of options.

Eventually it decides upon the Christian tradition, on the basis that it continues to suit my narrative, but it's almost immaterial which path it sets its tiny green feet upon, the outcome will be very similar. More choices await.

Now, we are into Catholic or Protestant, orthodox or non-conformist territory. Methodist, Baptist, Southern Baptist, Church of England, Church of Scotland, Quakers, Wee Free Church, Seventh Day Adventists, and so on and so on for rather a long time.

You see where this is going don't you? Even choosing the Church of England our new friend will be faced with low or high church, formal or informal, right down to the whims and preferences of the vicar and congregation. Pro or anti women clergy, for or against gay marriage? Frankly, the choice for our friendly alien is as staggering as it is illogical.

In the interests of full disclosure, people very close to me are committed Christians.

My love for them is vast and in their faith, they display compassion, social justice, acceptance of the huge diversity of the human condition and are generally pretty swell people.

In fact, their attitude to challenging racism, sexism, the patriarchy, and homophobia, to pick some examples, is an inspiration to me and not at all dissimilar to the attitude of most reasonable people, including those in the anarchist community.

My argument here is that what you, bright little poppet that you are, choose to believe is entirely yours to own. Virgin birth, okay. Quaffing beer in Valhalla, no issues. Incense and candles, that's fine and dandy. Pentagram and goats, all good. Anything that impinges on another person's liberty or influences the state to follow its teaching, no thank you.

Personal belief is just that, but start to use it for social control, to subjugate or make laws and you've overstepped the mark. If your God is so great and powerful, and I honestly don't know if they are or not, then they probably don't require fawning and sacrifice, they don't need prayers and tokens.

If a congregation are moved to work towards a better community then that is wonderful and I support it, no matter what the faith of that congregation may be.

Many of the food banks that are so in demand now are organised by The Trussell Trust, a Christian organisation. I volunteered at one for a while and in my experience, it was non-denominational, didn't once try and push religion and was a lifesaver for many.

One shouldn't discount the tendency for belief in a supernatural deity to sidestep or deny science and clear critical thinking. It's a similar argument for people who believe in homeopathy, it may not do harm directly but indirectly it undermines evidence led science[11].

[11] Nope, I'm not apologising. If you believe in homeopathy, sort yourself out.

Which of course some religious teaching does. There has never, as far as I know, been empirical evidence to prove the existence of any deity or the effectiveness of prayer.

One may think that the UK has sensibly discarded blasphemy laws, but Northern Ireland still retains them and for now at least that is part of the UK.

And this is from the UK Parliament website:

"Prayers

Sittings in both Houses begin with prayers. These follow the Christian faith and there is currently no multi-faith element. Attendance is voluntary.

House of Commons

The Speaker's Chaplain usually reads the prayers. The form of the main prayer is as follows:

"Lord, the God of righteousness and truth, grant to our Queen and her government, to Members of Parliament and all in positions of responsibility, the guidance of your Spirit. May they never lead the nation wrongly through love of power, desire to please, or unworthy ideals but laying aside all private interests and prejudices keep in mind their responsibility to seek to improve the condition of all mankind; so may your kingdom come and your name be hallowed.

Amen."

Amen indeed. Attendance may be voluntary but it is still the only option put before the decision makers. It calls upon God to guide them, yet the floor of the house is not exclusively Christian, and even if it was, the rest of the population that they supposedly serve certainly isn't.

According to the Humanist Society, over half, 53% of people surveyed in the UK profess to have no religion. Only 37% are Christian, 7% accounting for all the rest.

The monarch is head of the Church of England, which despite the recent inclusion of other faiths in the constitution that we don't have, still puts the Church of England at the seat of power. Parliament, Church and State are intrinsically linked.[12]

Again, from the UK Parliament website:

"Parliament has been a dominant force in shaping the religious life of the nation. The Church of England was created by parliamentary statute, and was protected from its enemies by further laws.

The Church is an integral part of the state and this position has been strongly upheld by Parliament.

Over time Parliament has responded to changing social realities and relaxed the laws on religious liberty."

Note - relaxed. Not abolished or reversed.

Our state has decided to lay back in the sunshine, slurp a cocktail and read a good book while keeping half an eye open for any deviant behaviour by its subjects that goes further than its smug, self-righteous liberal paternalism permits.

While we may exercise our right to stay away from places of worship as grown-ups, it is still the law in England and Wales for all state schools to hold a daily act of worship that is *'Christian in character'*. Many schools sidestep this or make a token effort. Nevertheless, our government could enforce it if they wished, and there are plenty on the right of the Houses of Parliament who would welcome such a move.

[12] The United Kingdom constitution is composed of the laws and rules that create the institutions of the state, regulate the relationships between those institutions, or regulate the relationship between the state and the individual. These laws and rules are not codified in a single, written document. *(UK Parliament website)*

Our state religion is pushed upon us, as if the only path to moral guidance is through the Christian church. It is indoctrination, nothing less. If a parent decides to remove the fruits of their love from their peers for the duration of this act of worship they get to be secluded and marked out as different at a time when that can have a marked effect on the developing young person.

Rootling around in a church not that long ago I found a religious book aimed at the very young. It was full of bright illustrations of happy children doing happy childish things. Playing, helping in the kitchen, going to the lavatory, sitting on grandad's knee, in the supermarket and so on. Under every picture was a reminder that whatever you are doing, to remember that God is watching you and that He knows what you are thinking and doing. At all times...

Replace the word God with Big Brother for the adult version.

It is just plain wrong to brainwash people in this way. They'll scream at 'lefties' influencing youngsters with their tolerance of homosexuality, women's rights and refugees[13] but refuse to consider the notion that forcing unquestioning obedience to an invisible deity upon the developing mind might just be worse.

After all, what is wrong with teaching children that being a good person, neighbourly and helpful is okay without the need to scare them into thinking that perfectly ordinary behaviours are policed from above? You can be a good, moral citizen without religion.

[13] To choose just three examples from many.

If the only reason you're not skinning cats alive and setting fire to Mrs Patel at number 45 is because God is watching maybe you need to think long and hard about that.

Undoubtably there are societies that operate under much stricter state religion controls than us. Our liberal approach is easier to live with as a free-thinking person than Saudi Arabia, for example, a state which enjoys our weapons of mass destruction but not our tolerant approach to religion and governance.

But we mustn't let the 'well, at least we don't live in [*insert name of other country here*]' position dilute our argument or distract from our own struggle to disempower the state. Constant in-fighting and squabbles over points like this are exactly the kind of distractions that engender statis in a progressive movement and, more importantly perhaps, are a joy to the state because while we end up tying ourselves in knots they can continue sipping G & Ts and basking in their arrogance.

We can break the invisible shackles of state religion, and the obvious first step is to truly separate the state and church for good. To do so we must face up to the prospect that the forces of law and order will come knocking...

"To steal from a brother or sister is evil. To not steal from the institutions that are the pillars of the Pig Empire is equally immoral."

Abbie Hoffman
Steal This Book
Pirate Editions / Grove Press

Law and/or Order

"A situation in which the laws of a country are being obeyed, especially when the police or army are used to make certain of this."

Once upon a time there was a wonderful kingdom. It was a magical place where everyone had their place allocated at birth depending upon whom they were born to. Everyone was happy and took great delight in their position. The high born were regal, ruled with benevolence towards their own kind and were grateful to God for the peasants he'd given unto them for their comfort.

The peasants, those who toiled in the big houses or in the fields, were merry folk who knew their place and were eager to please their overlords. Food was abundant and warmth and comfort were in good supply. Not to the peasants of course, who knew their place. Some of them survived infancy and were grateful for being allowed to do so.

Between rich and poor there emerged a merchant class. This suited the highborn, as no longer would they have to mingle with the grubby ones beneath them. Verily they rejoiced.

The peasants could now buy back the food they had produced, the wool they'd sheered and spun and the wood they'd chopped. The lords and ladies realised that starving people made poor workers and thus they paid them enough to patronise the merchants and keep the wolf in bailiffs clothing from the door.

Occasionally some ungrateful wretch would take what wasn't rightfully theirs, a crust of bread or a rabbit from the land they didn't own. They were dealt with justly and with a harshness that was designed to discourage the destitute and starving from stealing from the fat and comfy.

After all, if people didn't know their rightful place in Gods kingdom, then there would be anarchy said the rich and powerful, and we don't want that do we?

Do we?

If you want an example of how the rich and powerful can eradicate a 'problem' like a poor underclass then cast your mind to Scotland and what has been dubbed The Highland Clearances. During the 18th and early 19th century the Highlands of Scotland lost three quarters of their population to sheep.

The problem was the locals, Gaelic speaking descendants of the old Clan system and subsistence farmers who had an established way of life which was impoverished by today's standards but functioned well and was largely cash free.

Sadly, the landowners, i.e., those who'd bought or inherited land, were living in an era of a monetarised economy and considered the indigenous people their property or barely tolerated trespassers who were 'incapable of improvement.'

By the 1750s a cross breed of sheep was introduced into Scotland. This hardy soul could withstand the harsh northern winters and so was a delight to the wealthy who could maximise the returns of their land by grazing sheep to their hearts content. The only fly in this woolly ointment was the locals, who littered the place in their untidy rags, speaking in a tongue no son or daughter of the empire could understand.

So, with varying degrees of brutality people were cleared from the land, the land that had been bought and sold from under their feet.

Some were just evicted while others were set rents that they clearly couldn't afford. Families were dispersed to the coast, to cities and sent abroad, notably to what is now the United States, Canada and Australia.

The land grab by the rich and powerful wasn't restricted to Scotland. In 1773 the Inclosure Act granted the right to landowners to remove 'commoners' from the land across the UK and was the cause of much misery and many deaths from starvation as rights were systematically stripped from arable land and woodlands.[14]

Punishments for what we'd now consider minor misdemeanours, like stealing a loaf to feed your displaced family, were cruel and designed to keep the poor in their place.

Meanwhile for some, crime was a way of life, particularly but not exclusively in the ever-expanding urban areas. Undoubtably there were the vicious and merciless among the villains, but poverty and exploitation by the wealthy drove many to the fringes where breaking the law was a necessity.

So far so predictable. Riches meant power and influence. Poverty meant working long hours to produce that wealth, being told what to do, and relying upon whatever scraps fall from the heavily laden tables of the well off to survive. The industrial revolution and the impact of factories added a new level of exploitation to the poor, including children who were considered little more than expendable moving parts of the great machines of industry.

[14] I've simplified the very complex, multi-faceted Highland clearances and Inclosures act for the sake of brevity.

Most small communities were self-policing for minor rule breaking. It was largely the job of locally arranged militia, constables or sheriffs and sometimes the army to enforce civil laws, which you won't be surprised to hear was often on behalf of the wealthy or the crown. Maintaining law and order in some form or another pre-dated the formation of a 'modern' police force, which began in Glasgow in 1800 and then Robert Peel's London Metropolitan police force in 1829.

In any official uniformed or militia capacity the role of enforcement fell to men, although sometimes working on behalf of a Queen or female landowner. The UK's first female police were volunteers, formed in 1914, with the first constable with the power to arrest, Edith Smith, appointed in 1915. Even then her main role was to try and curtail prostitution, drunkenness and larceny among women.

Now we have a police force that lets people join regardless of gender, race or sexuality, even though a significant portion appear to be straight white men who are intent on keeping their slimy grip on the reigns of justice by undermining anyone not in their club.

Baroness Casey's review of the Metropolitan (London) Police published in March 2023 stated that *"Met officers are 82% White and 71% male, and the majority do not live in the city they police. As such, the Met does not look like the majority of Londoners."*

She went on to identify systemic failures and..." *We have found institutional racism, misogyny and homophobia in the Met..."*

Its worth reading the report, or at the very least the summary. Search for her report, it is published on the Met police website - met.police.uk

We mustn't forget that not all law breaking, however you define it, occurs in uniform or beneath a white collar. Putting a brick through Selfridges window may be an attention-grabbing lark but popping into next door and helping yourself to a laptop is not on.

Feeding your children isn't an excuse to shoplift, even from Waitrose. It may be a reason, so scampering out the door with a bag of samosas tucked in your pocket might feel justified, but the act causes stress and possibly even blame to the staff working there to support themselves and their families, the retailers prices rise to compensate repeated theft and ultimately everyone suffers except the shareholders, whose dividend will be kept lucrative by the consumer and staff having to shoulder the price hike.

Further up, or down depending on your perspective, lays the judiciary. We have a two-tier system, civil and crown[15] and that gives me a faint tingle of hope. The civil courts, run by magistrates, could be reformed to properly reflect the community they serve. Laws will need restructuring and 'punishments' too, but in essence if we could get magistrates that generally reflect society and understand their communities, and not just the tree lined avenues they live in now, then we'd be making progress.

The Crown Courts though are littered with the bewigged Oxbridge classes who preside over serious crime and matters pertaining to the state. The most obvious being treason, although that's a malleable charge at the best of times.

[15] Again, it's a little more complex than I'm making out to be but for arguments sake these are the important distinctions.

The class distinction here is stark and needs attention. Quite why one must be bred to judge others is bewildering, it's clearly a case of us still being judged by our 'betters'.

A simple solution would be to disband the crown court altogether, although I accept that some cases need specialist input, tax fraud for example, but a judiciary of peers could still include experts.

While here, we could also dismantle some of the complex and self-serving framework around the legal professions that leech off us: solicitors, lawyers, and barristers I'm looking at you.

If one accepts, and cards on the table I do, that we'll not all climb aboard the good ship Anarchy and sail into a utopian crime free future soon, then we need a new approach that doesn't favour the state, the wealthy or powerful.

It's a blurry line between policing and serving the state. Finding a way to do the unpleasant but necessary jobs of the police, but free of corruption, racism, homophobia and misogyny won't be easy. History has taught us that humans have a knack for messing up a good idea. Egos, inexperience, greed, and corruption must be expected and called out, providing a community led public service that is positive towards women's issues, child protection and equality. We need a force that is demilitarised and non-political that answers to the people and not the government.

We also need that force, or a branch of it, to go after the tax dodging corporations and the squirming between the cracks money launderers of high finance, that tackles the banks and hedge funds, the capital investors who destroy businesses to line their own pockets and so on ad infinitum.

The point is, we have laws that protect the 'great and the good,' for example the Inclosures act mentioned earlier is still in force today. If we stop thinking of law and order as top-down impositions but instead as positive protections of our rights and liberties then we'd be making progress.

That'll mean undoing a lot of the laws we have and those we retain being redrafted in different language.

It'll also require us to completely change the culture of our police. That, I fear will be another huge challenge. One that's beyond me because I can't see much of a way forward unless what we have is completely dismantled and rebuilt. We could start with rooting out the prejudices that seem endemic among the policing classes.

"*There is little hope for us until we become tough-minded enough to break loose from the shackles of prejudice, half-truths, and downright ignorance. The shape of the world today does not permit us the luxury of soft mindedness. A nation or a civilization that continues to produce soft minded men purchases its own spiritual death on an instalment plan.*"

Martin Luther King, Jr.
The papers of Martin Luther King, Jr. Vol VI
University of California Press at Berkeley and Los Angeles

Prejudice

"An unfair and unreasonable opinion or feeling, especially when formed without enough thought or knowledge."

Prejudice covers a multitude of sins...or more accurately, not sins.

Race, gender, sexuality, disability, I'm sure you can add plenty of other examples. Let us not spend time debating each point, because bigotry never comes from a positive perspective. Case in point. Prejudice against people who are gay.

What two or more consenting adults of the same species get up to is entirely their affair. You or I have no right to interfere, prohibit or impose a moral position upon them beyond a wider appreciation for societal wellbeing. So, no to force, coercion, or violence, for example.

The same applies to racism and a myriad of other prejudices. We should adopt a humanitarian, all-embracing policy towards others. Except, we don't. We might accept people as bags of meat wrapped in various exciting wrappers and understand the said meaty contents has arrived via a variety of pressures, cultures, education, and experiences that have shaped the bits we cannot see, and sometimes the bits we can. So far so good.

But do we accept them if the sum of their pressures, cultures, education, and experiences have shaped them into a rampant capitalist evangelical Christian racist misogynist homophobe?

To which I would answer, absolutely not.

I would however counsel that they deserve the opportunity to be dissuaded from their position and guided towards appreciating the world as a more subtle and nuanced place than their blinkered pseudo-fascist stance. Failing that we are left with protest, de-platforming, non-violent resistance, drowning them out, or repeatedly beating them with a big stick.

I understand the position that freedom of speech could embrace all positions, but if the repeated demeaning of people leads to their depersonalisation and thence onto being a lesser citizen without equal rights then we're bordering on fascism. Lines in the sand need to be drawn and challenging prejudices that infringe others liberty is a good place to start.

During the late 1970s and early 1980s Rock Against Racism (RAR) was established to fight the then resurgent National Front (NF), a fringe political party that was polling well in local and national elections on the back of an extreme right-wing agenda. RAR was formed from the Trotskyist Socialist Workers Party and along with the Anti-Nazi League they helped overcome the threat of the NF with cultural events like gigs and by protesting at NF marches.

Unlike most RAR gigs though, anarchist bands like Crass and Poison Girls held an open-door policy and used the opportunity to try and educate the Nazis who came along. They took the view that most were disaffected young people with few prospects, and educated them on the real villains, the politicians and press who were orchestrating the hatred, rather than the immigrants and people of different colour who were easy targets.

Anarchists weren't the only people to engage them in debate rather than smack a few shaven heads together, but they certainly took a more nuanced and pragmatic approach than the dogmatic Trotskyists.

Which isn't to say that standing up when necessary and resisting the rise of fascists by any means necessary, up to and including fighting back isn't an option that we should dismiss. But I don't believe it should be the first line of attack. Better to convert people than risk entrenching their views by creating a siege mentality among their ranks.

I dislike the violent option on principle, but there is a case to be made that when a nation or group therein becomes so powerful that they threaten the greater good, the Nazi party in 1930s Germany for example, resistance is necessary and the sooner the better if we are to avoid a repeat of genocides like those led by Hitler and Pol Pot.

Resisting the depersonalisation of ethnic groups, of people who are gay, immigrants or people with a disability is the first step.

We may not be able to get prime culprits like the printed press to stop immediately, but inspiring their readers to think for themselves, using reasoned, thoughtful and non-aggressive arguments may just start to change the landscape.

And if being called a woke snowflake detracts the idiots from calling people niggers and wogs then I'm okay with that. The fact that most of the offensive 1970s sitcoms like *Love Thy Neighbour* with its regular use of phrases such as *"nig-nog"*, *"spade"* and *"Sambo"* or the dreadful *Curry and Chips*, a Spike Milligan penned sitcom in which Spike blacked up and regularly used the term *'paki'*, are no longer acceptable on mainstream television is testament to the idea that we can, as a society, change.

Of course, Love Thy Neighbour and its ilk have their defenders, many of whom are racist buttholes who don't see the problem with bombarding people with dehumanising pejorative language. One or two do surface who see a few positives, Linford Christie for example, the Jamaican-born British former sprinter pointed out on Desert Island Discs that he and his father watched Love Thy Neighbour because it was good to see black faces on TV in an age when that was unusual.

It might be churlish of me to point out that Linford now has an OBE so is very much a part of the establishment, so I won't point it out.

As a record collector I often trawl the racks of vinyl on charity shop floors. Among the Val Doonican and John Denver LPs one can often stumble upon old Black and White Minstrel Show recordings. This was the nadir of light entertainment. A weekend 'highlight' of blacked up white musicians playing jolly tunes to celebrate slavery and the white man's privilege. Maybe that wasn't exactly how the participants saw it, but it was awful in just about every respect.

This wasn't seeing black faces on TV in a way acceptable to Linford Christie. This was avoiding putting real black faces on TV by getting white people to play obscene caricatures. Even this has its defenders.

They are wrong.

Let the newspapers churn out their hate, their defence of racist situation comedy on prime-time television.

The printed press is an anachronism, a wounded and dying animal lashing out with spite at easy prey to try and convince itself that it's as young and virile as it once was. We might as well revel in the hate filled rhetoric spewed out on its pages in the knowledge that its circulation is ever decreasing and will never recover.

As its readers die, they are replaced by generations of technology savvy people who get their news from other sources, although of course one can't vouch for their reliability. The internet may have democratised the flow of information by removing some of the traditional gatekeepers of news and opinion, like press barons and rich owners, but that doesn't necessarily equate to reliable news.

In the meantime, those of us with a wider, more compassionate worldview will remain, in their eyes at least, 'woke'.

"If you say
"You're not allowed to say"
What you just said
Then you're an idiot"

James Domestic
Extract from Free Yak, Cruor, James Domestic &
Dave Cullern.
Independently published.

Woke

"Aware, especially of social problems such as racism and inequality."

The word woke, used as an adjective in the above context rather than a verb meaning the past tense of wake, is a contentious issue.

But it shouldn't be. What is wrong in any civilised society with being aware of social issues like racism and inequality? Like its unfashionable fore-runner Political Correctness, it's been weaponised by the indolent, unthinking, and rosy nostalgia brigade to mean anyone who thinks there aren't enough black faces on television or that Dr. Who can be a woman.

It's all nonsense, a way to demonise socially liberal values. The barely literate who post on social media and write to their local newspapers will tell you that *"you can't say 'THAT' anymore"*. What 'THAT' is becomes a moveable feast, from manhole cover to Nigger, with a whole range of slurs, insults and completely idiotic made-up lunacy in between.

To start with, as you are reading this it's safe to assume that I haven't been dragged off to a Gulag in Brighton for political reprogramming for using 'politically incorrect' terminology. Indeed, one may use any number of racial slurs, Spic, Wog, Coon etcetera. Whether you can do so without consequence is another matter, and I hope my use is seen for what it is, an ironic example.

The same bunch will call out people who espouse kindness, tolerance and 'woke' values as snowflakes.

Our Prime Minister Rishi Sunak has called for people who 'vilify' Britain to be deradicalised. One assumes that vilifying Britain means the version of Britain he and his Tory chums want, not the one that has working people at its core.

In an equally bewildering, but sadly not surprising development there is a move to widen the protection of free speech to combat 'wokism'. Apparently, our free speech is being restricted because of fear of causing offence. This has led, with grim inevitability, to the rise of so called 'cancel culture'. Over the hill 1970s era comedian and right-wing whinge-bag Jim Davidson is touring as I write this under the promotional banner – *"Jim Davidson – Not Cancelled Yet Tour."*

There is a danger, to him at least, that he will be cancelled. Not by a bunch of commie students demanding his testicles on the barbeque, but because fewer and fewer people want to listen to a sweaty bloke telling mother-in-law jokes and bemoaning everything that they don't understand, before they die in a puddle of their own delusions of stardom.

He can tour and say what he likes to whomever has the gumption to attend. The reason he may be cancelled is because of low ticket sales. There is no law that restricts his freedom to say what he likes, beyond very broad parameters that even he is unlikely to stray into. Let us be clear here, no one is being 'cancelled' to restrict their free speech, it's because they're rubbish.

The occasional refusal to genuinely permit someone a platform to espouse radical views is one of those double-edged swords.

If it's a right wing racist homophobic comedian the powers that be will claim they're being cancelled by a load of woke snowflakes.

If a platform is given to someone the right doesn't agree with, they'll be equally upset that they were given a platform.

As I apply the finishing flourishes to this book football pundit Gary Linaker has upset the cosy applecart by comparing the Conservatives and their allies in the press with fascists. I shall not dwell on it here, but suffice to say those who object to what they call woke cancel culture are vociferous in their calls to , er...cancel Lineker.

A lot of the criticism of Jeremy Corbyn bore this out. As a young activist he shared a platform with people who might be considered terrorist sympathisers or anti-Semitic. Both cases were probably true, but apparently free speech can only exist to the right of Winston Churchill and not to the left.

Not that I, or Jeremy for that matter, were agreeing with terrorism or anti-Semitic sentiments. If you think one should never share a platform with a terrorist sympathiser then search online for the photos of the recently departed Queen Elizabeth II and Boris Johnson with Martin McGuinness, former military leader with the 'terrorist' IRA.

The threat from the 'woke snowflakes' and cancel culture doesn't exist, except in the mind of politicians who see a way to enforce more social control over us and the press who serve them.

On Tuesday 19 July 2022 much of the south of England was in the grip of a heatwave. In a wonderful piece of journalism (I'm using the term in its loosest possible sense) The Daily Mails headline was **"Sunny Day Snowflake Britain Had A Meltdown"**.

It went on to bemoan the fact that some schools closed, workers stayed home, shops shut and public transport suffered.

In Daily Mail world this was a sign of weakness and wokey snowflakedness.

On Wednesday 20th the same paper headline ran... **"Nightmare Of The Wildfires"** and went on to detail how homes went up in flames as the UK sweltered on the hottest day ever recorded here.

Oh, how they would have laughed as wildfires engulfed school playing fields full of children too dehydrated to flee. The Tuesday headline and story was a typical piece of hate fuelled right wing reporting. In a world beset with wars, hunger, disease, human rights abuses and climate catastrophe they chose to lead with a non-story about how some people and services responded to unusual weather, then completely reversed their position the following day when the 'snowflakes' were proved correct.

Undoubtably a bit of resilience as you grow up is a good thing. We need to learn how to be assertive without aggression, how to turn mistakes into a learning experience and so on. But being bullied as a child, or an adult, is a horrendous, esteem sapping experience that isn't acceptable. The problem is, one doesn't know the background, life experiences, neurological 'wiring' or anything else about another person, so what may be carefree banter or a 'robust' work culture that is acceptable for one person may at the same time be intimidating and bullying to another.

It goes deeper than that though. The way women, people with disabilities, black people, people of non-white Christian culture, the elderly, non-binary people, gay people and so on have been treated and portrayed through history is sickening. Having a role model that reflects your experiences and culture is important. In literature, on TV and film, in the media and in your elected representatives in parliament.

Labour was ridiculed by the right-wing press for having all women short lists for MP selection. If around half of the population is female, why then shouldn't the decision makers reflect that? Even now it's around 34%, which is abhorrent, unrepresentative, and undemocratic, but then our parliament is only an illusion of democracy, as discussed elsewhere in this book.

Even comparatively recent history is full of examples of white male dominance. The move to universal suffrage was opposed by all sorts, from the ridiculous to the mind numbingly sexist. Although women can vote now, attitudes have been harder to change and our society still hasn't adapted to equality in anything like the way it could or should. The examples are many and varied, representation in parliament is just the tip of a fetid iceberg of overt, and clandestine, oppression that keeps the little woman in her place.

The same can be said for so many people, and our parliamentary system doesn't permit much except token representation when an MP decides to champion a particular cause or minority group. Of course, no group in society is homogeneous to a particular point of view.

People who have a learning or intellectual disability are not all going to vote (if they are permitted such a 'privilege in the first place) or think the same way. The same for everyone else. Women's issues transcend party politics but get dragged into the win/lose ethos of our system simply because we think in binary terms tied to, yes you guessed it, our rigid parliamentary first past the post system.

Woke isn't about how one thinks.

I know plenty of people who try to live moral, non-discriminatory lifestyles but would hate to be thought of as woke.

Using the term in a pejorative sense is another example of the binary thinking we should be challenging. It's a label. A lazy way of corralling everything or everyone you don't like into a single word. Like political correctness before it and numerous other insults and collective terms it acts as a short cut to our prejudices.

We all do it. I tend to refer to Tories as a group, implying that they are all self-serving capitalists with no redeeming features. But the reality is different. Many are decent people, I know a few and none of them are the personification of evil. They just have different opinions to me.

I reserve my real scorn for the rich and powerful, the parliamentarians and products of privilege who accept their supposed right to rule without thought.

Anarchism is a broad church, a label that challenges those who would oppose it because they think it means lawlessness. As a philosophy that label is a jumping off point for a discussion about its true meaning as a political movement.

Being 'woke' isn't a bad thing if you choose to accept the label, but it is still a brand applied by those we oppose. It is annoying but nothing like the dehumanising slurs many minorities have had to endure. What we can do is simply persevere and not let them get under our skin.

Creating safe spaces can be a meaningful way to encourage the voiceless to have a say, without fear of intimidation or bullying tactics. That isn't to negate taking responsibility for one's words and deeds, but it does protect those who may be intimidated by the more vociferous among us.

Far from being a soft, woke example of snowflake culture they are a response to White, Might, Right, and Male dominance. A way to encourage honest and fruitful discussion in a positive atmosphere.

It's easy to fall into the trap of identifying people with certain views as a homogeneous group, so I will...let us put our passports into our back pockets, grab a bar of triangular chocolate and some neon-coloured alcohol and pop over the border to Little Engerland.

"*The plague of racism is insidious, entering into our minds as smoothly and quietly and invisibly as floating airborne microbes enter into our bodies to find lifelong purchase in our bloodstreams.*"

Maya Angelou
Wouldn't Take Nothing for My Journey Now
Bantam

Little Engerland

"Slang, UK, football chant"

Here they come, the self-pitying Little Engerlander racists.

These are the people who would volunteer to be guards at a concentration camp. They whinge about a Muslim invasion and claim this is a Christian country but lack the tiniest shred of humanity associated with religious teachings. They responded to Black Lives Matter with 'All' lives matter, but forgot to add, *'unless that life is wrapped in a darker skin than me'* on their Facebook rants.

They want to protect our borders by selling arms to the highest bidder and then refuse to shoulder any of the responsibility for the resulting carnage and refugee crisis.

They want to defend the union but could not find Scotland on a map. Of Scotland. They hate the EU, love the Commonwealth, and think they embody the spirit of a snarling bulldog wrapped in a union jack waistcoat.

They're just like real bulldogs, inbred wheezing lumps of drooling fat.

It is a sad, lonely little world in Little Engerland. A place where the border is buttressed by fermenting back-copies of the Mail and Express, Nigel Farage is their saviour and they bend the knee to no one except the King, because he represents their fictional 1950s sepia vision of a United Kingdom where kids could play in the street, burglars wore stripy tops and carried bags labelled SWAG for easy identification and every street had its own policeman who was allowed to flog children and shoot gypsies.

When their lager-fuelled lungs sing God Save the King at the football, it's not the middle eastern Jesus or the God of love and peace to whom they refer. Much more up their street is the Old Testament God of fire and brimstone, the God who obliterated Sodom and Gomorrah and demanded sacrifices. The God who wiped out most of humanity with a flood; that one.

They abhor health and safety legislation because they managed to survive a time before injury and mortality rates declined by up to 70% for children. Consequently, they label everyone born after 2000 a snowflake because they have safer climbing frames in the school yard and didn't smoke in bed before the age of 13.

People on their televisions and the cinema screen were almost always white, men did butch things while women simpered and everyone stood at the first note of the national anthem. They believe that the ultimate resistance to 'political correctness' is to share a Facebook post of a gollywog.

They are old enough to cherish warm memories of Robinsons Jam adorned with cheerful caricatures of black people on the label. Remember them?

The Golliwog began life as a story book character created by Florence Kate Upton, published in 1895. It was based on black face minstrel rag dolls she had played with as a child. Whatever her intensions it quickly evolved into a grotesque caricature, with jet black skin, large, white-rimmed eyes, red or white clown lips, and wild, frizzy hair. It was adopted by Robinsons in 1910 and, with a couple of short breaks, was synonymous with the brand up until 2002. They had all sorts of merchandise based on the Golly too, badges, figurines, and suchlike.

In 1979 professional irritating twat and ex conservative MP Gyles Brandreth published an illustrated children's book called *Here Comes Golly*. It must be good, it has three reviews on Amazon, including this one by Dr. Gillian S. Hayes, '5.0 out of 5 stars. *'Good old golly! Exactly what I wanted for my grandson who loves his golly! Pity they're not PC any more.'*

I've no idea if she really is a doctor and if so of what, rose tinted nostalgia and casual racism maybe, but her last sentence sums it up perfectly.

'Pity they're not PC anymore'. I bet the good doctor belongs to some Facebook nostalgia sites. You must have seen them, the sort where people post things like *'The council are rubbish because they've put a bus lane along a road I never go down'* or *'I was spanked with birch twigs twice a day and made to crawl over broken grass to fellate the parish priest but it never did me any harm...'* that sort of nonsense.

Among the worst offenders, to my mind anyway, are the variations on - *'How far can this get before Facebook removes it?'* above a picture of something that isn't considered 'PC' anymore, such as a gollywog - memes that a Little Englander defends.

They've weaponised nostalgia for their own ends and defend their right to spread racist nonsense. In their eyes they are correct because that is how it was in their day, so there you go Sonny Jim, that's settled.

The argument is that they did not see it as racist, and no racism was intended, so how can it be racist? Which is like saying I painted swastikas on the synagogue gates as an expression of solidarity because it's an ancient symbol of divinity and spirituality, so what's your problem?

Cunts.

Sorry for the swear, I didn't mean offence. In fact, the word probably comes from a 13th century London Street (Gropecunt Lane) and wasn't a taboo word until the late nineteenth century.

So that's fine, nostalgia + that's the way it was + no intention to offend = if you're offended by the word cunt you must be a liberal snowflake.

Go and join the army, shoot a few foreigners and come back when you find Roy 'Chubby' Brown funny.[16]

Okay, maybe it isn't that simplistic, but racism isn't just about the obvious knuckle dragging skinhead gangs and neo-Nazis. It's about depersonalising people, creating difference and keeping people 'in their place' by the acceptance and normalising of symbols like gollywogs and derogatory terminology in everyday life.

And statues of slave traders and colonialists looming over us as we pop out to the shops.

It's about the constant stream of undermining by the media, especially the newspapers, who relish the opportunity to add 'colour' to their crime stories. It's about rabid and emotive anti-immigration rhetoric rather than nuanced debate, it's about blotting out those awkward elements of history like imperialism, slavery and mass murder (think aboriginal Australians for example), it's about celebrating Churchill and ignoring his part in the debacle that was Gallipoli or bombing Liverpool,[17] or venerating Florence Nightingale and ignoring Mary Seacole.

If you had to look up one of those people, I'll bet it was Mary, wasn't it?

[16] Sample material - "I'm not saying that all Muslims are terrorists, but isn't it funny how all terrorists are fucking Muslims?"

[17] Yes, he planned to, more about this later.

It's about Gollywogs on jam jars and splashed on social media, and it's about not giving a flying fig about anyone else's feelings because you once collected Gollywogs from the side of jam jars and are too pig ignorant to understand that the world doesn't revolve around you and your nostalgic wet dreams.

The world has changed.

If you feel left behind, you could just sit there in a puddle of hatred on the sofa you've had for so long it's still got the stains from when you masturbated to 70s sitcom 'Love Thy Neighbour' with its jovial *"You can't reason with a Sambo, they haven't got the intellect"* quips...or you could try thinking and changing.

Maybe stop being a cunt.

The world of anarchism and freethinking is littered with ideas and philosophies that bounce around like elements in a hydron collider, occasionally joining forces, sometimes attracting, sometimes repelling, occasionally igniting. I'm at the end of a rather dubious foray into physics metaphors, a subject I know precious little about so, moving on...you could put an anarchist in a room on their own and they'd find cause to argue with themselves.

It's a fractured and diverse term embracing many ideologies but, here's my point...nearly every anarchist school of thought, and most similar philosophies, share a basic regard for humanity irrespective of gender, race, creed, education, nationality or upbringing. Being anti-racist doesn't make you an anarchist but being a racist is almost certain to exclude you from any anarchist's birthday card list.

We just need all the woke 'snowflakes' to join together into an avalanche.

We can Leave Little Engerland behind and ignore all the jingoistic bullshit and crass sentimentality that often accompanies it and move on.

Now, about that sentimentality...

"When you go for a walk, take seeds with you, poppies, rainbow chard, rocket. Plant them among the weeds in patches of wasteland. See what happens."

Tom Hodgkinson
How to be Free
Penguin

Claptrap and Poppycock

"Absurd or nonsensical talk or ideas."

As the Covid-19 lockdown hit its stride in 2020 a curious phenomenon took off. We were encouraged to clap for the NHS. This grew to become a state encouraged display of general socially acceptable anti-social behaviour on the streets of Britain. Applause was deemed a great way to say thank you to the front-line workers of our struggling health care network.

At first it was a polite and well-intentioned display of gratitude as health care workers struggled on the front line. However, it quickly became a politically motivated coup by the ruling Tory party, endorsed by the opposition of all hues, to position sentiment over reality. While people died alone in care homes and struggled for their last breath in hospital corridors, we were encouraged to clap to express our gratitude to the staff barely able to stand as years of underfunding, political interference and poor management combined with a pandemic for the perfect storm.

Now, let me be clear, the NHS is an institution that I think should, and could, work properly and to all our benefit. Its staff, across the board, are underfunded, poorly rewarded and largely ignored by the state unless they are asking for more money instead of a ripple of applause.

I was among their number for many years, I've seen the good and bad sides of the NHS from within. Incidentally, as a one-time union officer I've seen the good and bad sides of unions too. I have no beef with the NHS as an ideal, nor with the 1.2 million (and that's just in England) staff it employs.

I did it because I was paid a reasonable wage for my labour, which enabled me to buy food and pay the rent and suchlike. It was a good fit and I mostly enjoyed it, but, and this I feel is the salient point, it wasn't a vocation into which I'd have willingly toiled for nowt but a warm fuzzy glow and a round of applause every Thursday evening.

We need to seriously question the attitude that a good hand warming clap makes up for years of underfunding.

Signalling our virtue by way of applause is almost as bad as festooning the family Skoda with Cross of St. George flags when the football chaps are playing Abyssinia in the Eurovision Cup, or sticking a poppy the size of a dustbin lid on your garden gate, rather than something descreet in their button hole.

I wear a red poppy.

I appreciate many people require support and that it's not forthcoming from the state. It also reminds me that I lost an uncle to war and my father witnessed the aftermath of the nuclear bomb being dropped on Nagasaki.

I also wear one because I don't want them to be a symbol of race hate or patriotic zeal as espoused by the brigade of union flag shagging anti-everyone-who-is-not-the-same-as-them Little Englanders. That said, while reviewing this chapter I read the following on the Royal British Legion website:

'Poppies are worn as a show of support for the Armed Forces community.'

Which is causing me food for thought. Every day's a school day.

As a non-political, non-partisan symbol, which I thought it was, it is powerful and shouldn't be divisive, although in strongly unionist regions, particularly Northern Ireland and parts of Scotland it has developed distinct political overtones.

Its association with remembrance of the deceased in conflict probably comes from the poem *"In Flanders Fields"*, written by Canadian Doctor, poet and teacher Lieutenant Colonel John McCrae, M.D while serving on the front lines in World War 1.

"In Flanders Fields the poppies blow,
between the crosses row on row..."

I often wear a white poppy too, partly because it's a non-sectarian symbol of peace and partly because some conservatives hate it. Tory MP and former army officer John Mercer called them *'attention seeking rubbish'*, a case of the pot calling the kettle black if ever there was one.

The first white poppies were sold by the Co-operative Women's Guild in 1933, so it's not exactly a new, attention seeking phenomenon.

It really isn't that big a deal, why not wear a red one or a white one, or both, or none, and mind your own business about what is or is not on someone else lapel?

Being able to choose to wear one or not is a powerful lesson in what we can take for granted.

I won't wear a purple one though.

Increasingly I've seen the purple poppy creeping in. This is to remember the animals that served and died to protect our freedoms.

Which is wonderfully sentimental and completely barmy.

The horse that dragged cannons to the front line of the Somme and took a bullet for Blighty didn't volunteer. There was no equestrian line queuing up outside the recruitment office, no ponies were refused front line duty for having flat hooves. They weren't patriotic creatures happy to give up their pasture to ensure that their foals could grow up in peace and free from tyranny. They were beasts of burden driven into action and terrified out of their minds.

Now, we could delve into all sorts of debate about whether members of the animal kingdom should be forced into our conflicts, or indeed any kind of 'service'. But we won't, well, I won't anyway. That is a question for your conscience to wrestle with.

What I'm more interested in is the absurd sentimentality we afford animals on the one hand and the barbaric treatment of them many accept as the norm on the other.

Weep for the dead war horse yet cheer the runners over the grand national course, with its toll of 55 dead horses since the year 2000.[18]

Those dogs that took a bullet for their handlers did so exactly because that's what they were bred and trained to do. They were not brave. Canines are fight or flight animals that we've exploited and directed to our benefit.

Of course, they are a loss, and it's okay to feel that loss. But if we accept that we have the right to harness their skills for our own ends and that we can drag them into our wars then we should expect them to be wounded or killed, exactly as we do every human who we put into uniform.

[18] As of March 2023.

But whereas human casualties had a semblance of an idea about why they signed up, or in times gone by were conscripted, animals have no loyalty to right or wrong, no concept of a nation state to support or cause to defend. Carrier pigeons didn't fight Nazis, they just did what they do for a few kernels of corn and somewhere warm to roost.

We even have an Animals in Conflict memorial in Hyde Park, London. It's all well and good but it's not the horses, dogs or pigeons that visit it to lay their wreaths. They are not the ones mourning their ancestors or marching past the cenotaph in a choreographed display of grief from the animal kingdom.

Is there a spectacle more hypocritical than laying a purple wreath at the memorial in Hyde Park then popping into the nearest gastropub for a plate of roast cow?

Maybe the best memorial we could have to animals is to stop messing up their lives for our own profit. That or stop the hypocrisy and accept that they have no more status in God's kingdom than a potted plant and are ours to slaughter as we like.[19]

We really can be a contrary species, ruthless and sentimental, cruel and kind and quite wonderfully ignorant, as I've found out in public facing jobs.

[19] Before you start composing an angry email, that a point of view to which I do not subscribe.

"The intellectual's hostility to the businessman presents no mystery, as the two have, by function, wholly different standards. While the businessman's motto is the customer is always right, the intellectual's task is to preserve his perceived standards against the weight of popular opinion."

Bertrand de Jouvenel
Capitalism and the Historians edited by F.A. Hayek.
Taylor & Francis

The Customer is Always Right

"Said to emphasise that in business, it is very important not to disagree with a customer or make them angry."

It may seem as if I have strayed from the intention of this book, but as I have preached discussion with people this is a reminder that not everyone will be receptive or easy to convert...so this chapter it is dedicated to everyone who works in a customer facing position. You are all delicious little morsels of humanity.

One thing anyone working in a customer facing position knows is just how awkward engagement with other examples of our species can be.

Which is where customer service experience comes in. You see, for all our arguments about moving from a binary Yes/No, Right/Left world, people from all backgrounds and experiences, from princes to paupers, are complex, sometimes irritating and often downright bloody annoying.

'The customer is always right' is one of those hoary old maxims written by the boss and not by you, the unfortunate bag of fleshy cynicism that must deal with other people on a day-to-day basis.

The boss may tell you to smile, be polite and friendly, impart information in a timely and efficient manner or whatever, but they cannot realistically expect you not to respond with a twinge of disparagement when confronted by dolts.

People are often demonstrably incorrect. Sometimes in error, occasionally through blatant dishonesty and now and then they are just plain stupid.

The mystery is why people with plenty of life experience, good jobs doing complicated things, who evidently possess more than just the ability to dress themselves unsupervised end up being complete pillocks when it comes to interacting with their fellow beings, particularly those whose job description specifies providing them with a service.

Of course, often the customer is right. Occasionally in a way that matters. Like pointing out a flood in the lavatories or food that has expired. Then they can inform you and bask in contented smugness for the rest of the afternoon.

Equally, sometimes customer service does leave a lot to be desired. I'm sure we've all had experiences with rude, aggressive or monumentally bored staff.

There are occasions when one wonders why a harridan with the face of an angry potato and the manner of a half-starved shark has stumbled into the one job that they are unsuited for. Why don't they retrain as a mortician or scarecrow rather than inflict their misery on the poor souls who amble into their orbit?

That's life I'm afraid. I'm not defending poor customer service here and equally I am not defending rude or impolite customers. They deserve each other.

But we are all working people, sticking together should be a basic part of our DNA.

Contrary to what you may think while reading this, I don't detest people. As I write I'm reminded of many wonderful and generous friends, family and colleagues that I share the planet with.

It's just that after a few weeks of working with the public one comes to realise that often humans appear in your life in their raw and unfiltered state.

You, the person providing a service, are just another obstacle between them and their enjoyment of whatever it is you are selling; ice cream, admission to the cinema or access to your genitals if your profession is particularly ancient.

After encountering all manner of customers in public facing roles, on one occasion I found myself telling someone exactly what I thought of their ludicrous complaint about the weather by apologising for not contacting them in advance to organise sunshine for their holiday. I instantly regretted it but my default setting seems to be sarcasm.

It's a part of me I've come to accept in the same way that I've come to understand that I have two legs, clusters of fingers and toes gathered around my extremities and a penchant for thinking no one else can hear me fart.

I realised it isn't just a character trait that stayed rattling around inside my head when my son tried to describe me to a friend. His description was, and I quote it in full... *'Did you meet a tall sarcastic man?'*

That was it. Not witty and debonair.
I'd have settled for balding and edging towards tubby. But no...sarcastic. That and the distance of my cranium from the floor were my defining characteristics.

My superpower appears to be the ability to be rude and acerbic with passive aggressive overtones while looking down at you.

Sarcasm was a handy way to deal with idiots at school, just moments before they hit me.
Shakespeare called it the lowest form of wit, but then he'd never heard Jim Davidson.

There is unquestionably a lot of aggression in sarcasm.

As I've said, I'm not proud and generally, as I bumble along through life like a somnolent pinball, I try to be a joy to be around. I think nice things about people I meet, I help old people across the road, give lifts to strangers and engage in a delightful and amusing way with customers and my fellow human beings, even those who don't share my political views or social concerns, who support the wrong football team or are otherwise misguided.

I mix with people of different political opinions and those who claim no interest in politics at all. I regularly meet people from overseas in my job, and I've come to understand that politics is in part cultural conditioning and part an amplification of our own traits.

To explain...What I consider right wing in the UK is left of centre in parts of the USA. I have some sympathies with libertarian causes, although they tend to be ultra-right with many policies that go against the grain with me.

People are generally inclined towards authoritarian or libertarian traits, there is a lot of research and some tests[20] one can take to determine where you may fall on an axis of left/right and libertarian/authoritarian.

It's all very interesting but I suspect it determines nothing of lasting value.

By way of an aside, out of curiosity I tried one once to determine who I should vote for. The result was Scottish Nationalist Party, which was all well and good but since I lived in Essex at the time not particularly helpful.

I now live in Scotland so maybe I'll vote for the Essex Freedom Alliance.

[20] I cannot vouch for their accuracy.

Anyhow, the lesson from all this is that we must learn to engage with people who will disregard anything outside the assemblage of permitted thoughts and ideas that they've been sold from the deceptively understocked department store of state education, parliament, and the other institutions of state.

Stepping outside their comfort zones is scary, it is for all of us, even those of us who want to see real, radical change.

Although fear of change and grasping genuine freedom may be strong, we should be more afraid of the alternatives.

"*Do you want to make it impossible for anyone to oppress his fellow-man? Then make sure that no one shall possess power.*"

Mikhail Bakunin
Quoted from The Political Philosophy of Bakunin: Scientific Anarchism
Free Press

What a kerfuffle

'A commotion or fuss, especially one caused by conflicting views.'

Where does all this get us and what shall we do?
Revolution is of course an option. But I'd counter that argument with the fact that it'll be highly unlikely to escape the forces of the press and vested interests of the state to get anywhere near happening. Part of the problem is that most of us have too much invested in a system that we fundamentally disagree with.

There's no blame intended, it's the system we were born into or that was wrested away from us by parliaments as they've lurched to the right. Council housing becoming the option of last resort for the most destitute rather than a sensible option for life, privatised transport, utilities and so on and so on...

As a result, many of us have mortgages as the only sensible choice to secure our family's future, we have bank accounts, loans and jobs that require varying degrees of compliance with a state we at best don't trust and more often despise.

It is beyond the remit of this book, and the ability of its author, to propose a viable alternative to the current mess that we've built. But then again, not sticking to rules and a lack of talent hasn't stopped me yet - so here goes:

Dismantling the structures that we have in place is more than mechanical. It's about hearts and minds, to borrow a phrase. Changing the way that we do things is hard but not impossible so long as the drive and will is there in the first place. Getting the majority, at least in key places, to agree is where the battleground is, so this is the first of many hurdles.

Before us are our young. They are being educated in narrow, politicised parameters, trained for the supposed needs of the captains of industry. Working people are hemmed into enclaves, patronised, and lied to by the media and betrayed by the Labour party.

Traditional industries, and with them communities, are clinging on by the fingertips or have already been turned into wastelands, where getting government assistance in the form of benefits is demonised by politicians and the press.

There's fertile ground there but it would be remiss to overlook years of neglect and well-intentioned but patronising assistance that have built barriers and resentment. On a more positive note, it is easier to see how dreadful our parliamentary system is when you're looking at it from a position as far removed from the hallowed corridors of government or the glittering ballrooms of palaces as you can get.

The wealthy and the power brokers, the Lords and Ladies, many members of parliament and the upper echelons of our society are too invested in the system to be allies in any meaningful numbers. They have more at stake and lots more to lose than you and I.

That leaves the 60% or so of the 'middle classes' who need to be allies of the working class.

Instead of lumping everyone together in poorly defined homogeneous groups, if we think of working people as those of us across working and middle-class backgrounds seeking the same goals, then a broader, non-binary political landscape can emerge.

With the correct engagement they might just see through the veneer of parliament and see it for what it is. Where working class areas may be fertile soil, the green fields of middle-class-land are deceptively deep rooted and will need attention.

They too watch the spectacle of revolving door politicians and follow unwritten rules just for having the tenacity to survive beyond infancy so that they can become a useless cog in a machine designed to keep them cogging away all day without complaint. A new car on hire purchase and a mortgage for a house they can barely afford, the trappings of a lifestyle sold by charlatans, shiny tokens of their thanks for being a compliant cog.

Now we need to engage with those people to change that coggy world. We don't need to lay down a path or get anyone to sign a pledge in exchange for a membership card. People can think for themselves, and suggesting reading material, on-line resources or just to question their diet of news channels and social media feeds is a start.

Yes, we'll face resistance on the ground, challenging the status quo won't be easy.

The message may need to be watered down from revolution, but seeds can be planted and left to germinate.

Maybe, to get the ball rolling we do nothing. Literally.

If the Covid inspired lockdown has taught us anything, it's that Joe Wicks is an annoying idiot, but also that the people who matter are us. The workers. No one missed the city traders and arms dealers, the advertising executives, or the Royal family. So, we could, you know, just stop.

Stop work altogether. A general strike if you will...those who can that is, maybe not the midwives or the person that makes cheese and onion crisps obviously, but most of us, until there's some movement towards meaningful change. An opportunity to get the message out about a broken system of government, politicised law rather than rules of protection and preserving rights and a monarchy that sucks out our self-worth to polish its tiaras.

As I write this rail workers, postal workers, bus drivers, university lecturers and nurses are all taking or considering strike action[21]. There are more besides as we slide into a winter of discontent fuelled by rampant capitalism doing what rampant capitalism does best.

Imagine if all those bodies now negotiating their way into withdrawing their labour were part of a national campaign that demanded change for a fairer society?

A world where we all count and no one wields the power to expect our subjugation just because they have a big crown and a pedigree that would put a Crufts supreme champion to shame or wear a crucifix the size of a baby around their neck.

[21] More since this was written, see the addendum.

Whatever route we choose, we need to convince people that what we have now - the big unwieldy state, monarchy, corrupt parliament, elite education for the benefit of the few, and privilege given a free pass over lived experience - needs urgent and thorough reform or abolishing altogether.

We need to grab the attention of our overlords by chucking a few more statues of Victorian racists into the harbour, hurling a few cobblestones through plate glass, choosing our own pro-nouns (that really seems to hack them off) and then stop supplying them with our labour until they agree to reform.

Or revolution and heads on spikes outside Westminster.

I'm easy either way.

"I should have liked to produce a good book. It has not turned out that way, but the time is past in which I could improve it."

Ludwig Wittgenstein
Preface to Philosophical Investigations
2009 Blackwell Publishing Ltd

Addendum

"An item of additional material added at the end of a book or document, typically in order to correct, clarify, or supplement something..."

The development of a book, from writing, revision and editing to publishing is time consuming. The real world of work and other responsibilities eats into precious writing time, extending an already protracted process.

It is then worthwhile rounding up recent events before bidding you adieu, which I have attempted to do in this chapter.

However, before we dive headfirst into the murky waters of life under our lords and masters in 2023, permit me a brief diversion.

I recently experienced a modest but significant example of how a smaller, localised world could, should, work. It was a painful but valuable lesson.

At work I was putting a heavy bollard into its hole, as one does, when for reasons I still don't understand I tumbled over it and executed a perfect face plant on the gravel.

A trip to Accident and Emergency (A&E) followed in case my nose was broken.

Now, the point to this story, apart from encouraging lashings of sympathy from you, dear reader, is that my waiting time, for what was a relatively minor, non-life-threatening collection of bruises and grazed ego, was a whopping 2 minutes.

Contrast this with waiting times in A&E of at least 12 hours for more than 54,500 people in December 2022. The target is to be seen within four hours, which was achieved for just 65% of patients in the same month.[22]

These figures are very conservative (and Conservative) because there are all sorts of inventive ways to massage figures by the hospital administrators caught between government-imposed targets and government-imposed cuts.[23] The reality is queues of ambulances outside hospitals and people being 'seen' but not necessarily treated within the target time.

The difference between my experience and most of the UK is that I live in a small island community with its own hospital. It serves around 3,100 permanent residents and about the same again during the busiest summer months.

Of course, I could be unbearably smug about it,[24] but my reason for bringing it up here is that our hospital, unlike so many community or cottage hospitals around the UK, hasn't been forced to close due to under funding and 'rationalising' of resources.

Which no doubt pleased the accountants and government ministers but failed to serve those they should have been, well, serving.

As ever with this shower...profits before people.

Doing things on a local, community led scale is achievable and practical though.

[22] NHS figures, retrieved from itv.com.

[23] They may tell you they have invested loads of dosh into the NHS but in real terms, taking inflation and population trends into account they've reduced its income considerably, and will keep doing so.

[24] I am. Sorry.

It works right up until the point the government get involved and tell us to bugger off with our wanting decent healthcare unless we are prepared to pay twice, once through tax and secondly through private health insurance.

I'll say it again, doing things on a local, community led scale is achievable and practical.

One must direct resources to where they are needed, they are, after all, our resources. They don't belong to some tweed coated buffoon in Westminster to dole out willy-nilly to whoever props them up or does their bidding.

If we remove our reliance on a first past the post popularity contest every five years, invest in our communities as and when they require it and stop them putting their chums, the bankers, corporate tax dodging multi-nationals and arms manufacturers[25] above ordinary working people in the food chain.

Its not hard. Its not rocket science, its just means re-evaluating our priorities, and of course the way to do that is to take control of our resources and distribute them fairly.

Maybe that's a dream, a vision of a utopian future that is impossible to actualise. But then the NHS was a dream - until it wasn't. The problems with it are top down and political.

And it turned out my nose wasn't broken, thank you for asking.

Now, where was I?

You may not be surprised to learn that since this volumes first draft life under the Tory regime hasn't improved. Nor has their opposition transformed into a radical party of revolutionary socialists.

[25] To give just a few examples.

One faint glimmer of hope is the Labour Party's proposal to abolish the House of Lords and replace it with a democratically elected second chamber. It may only be tweaking with a broken system but it is at least an acknowledgement that what is in place now is beyond redemption.

Elsewhere, the Tory party chairman Nadhim Zahawi has been sacked for a *"serious breach of the ministerial code"*. The serious breach in question was being caught lying about his tax affairs. Note it was the lying that did for him, not his underhand tax dealings.

Our energy bills are estimated to rise by an average of £900 per household during 2023, plus a bonus rise of £700 on average in household tax.[26]

Meanwhile pay packets continue to shrink in real terms, hours are being cut and workers laid off as companies and small traders' struggle.

If you put the heating on in 2022 you might have been one of the 3.2 million households who couldn't afford to top up an expensive pre-payment meter.

Or you might be among the 1.3 million who received a food parcel from a Trussell Trust food bank in just 6 months of the year, 52% higher than 2019.[27] Half a million of these parcels were distributed to children.

One in five people referred to food banks in their network was to households where someone is working.[28]

Little wonder the Citizens Advice service saw a 229% increase in calls during 2022.[29]

[26] The Resolution Foundation
[27] The Trussell Trust -1 April 2022 and 30 September 2022
[28] The Trussell Trust
[29] Citizens Advice

In Scotland the ambulance service has reported that between 1 and 18 December 2022 it took an average of 44 people a day to hospital suffering from hypothermia. That's 800 people.

170 of those were in Glasgow, they weren't living in out of the way crofts in the Highlands with powerlines down, these were regular people who simply couldn't afford to heat their homes because of soaring energy costs.

Also in Scotland, doctors in the group *GPs at the Deep End*, a network representing doctors working in surgeries in the 100 most deprived populations in the country, reported record levels of malnutrition, due, they say, to nutritious food being swapped for cheaper, energy dense foods.

One of the reasons is that food banks often cannot supply fresh fruit and vegetables so as people's reliance on them grows so their health can deteriorate.

Things can only get better, or maybe not.

On the 31 January 2023, the International Monetary Fund, about whom I know little and trust even less, announced that the United Kingdom and Northern Ireland will be the only major economy to shrink during 2023. Now, we all understand that international monetary organisations are, by definition, invested in the economy of capitalism and part of the problem, not the solution, but to overlook their predictions on that basis isn't helpful right now. They know what they are doing, even if we don't approve. In a nutshell, they are saying the working folk of the UK are screwed because of our capitalist masters.

If one pauses for thought, the notion may occur that that's the type of dire warning that they and their ilk give when anything vaguely socialist, or left of centre for that matter, is proposed.

Economic chaos may not be the preserve of the left after all.

As if to prove my point, having hidden from public view for a while, apparently to recover from an irony bypass, Liz Truss has now declared the failure of her budget to be the fault of the *'left-wing economic establishment'*.[30] One almost feels sorry for her as the Daily Telegraph headline writers sharpen their quills and put her delusional ramblings on page 1.

Her successor, as well as the opposition parties, continue their predicable merry-go-round of petty insults and name calling, seemingly oblivious to the widespread unrest spreading across this green and pleasant land.

Teachers, university lecturers, nurses, rail workers, ambulance staff, postal workers, civil servants, physiotherapists, and firefighters are on, or about to go on, strike, and numerous other disputes rumble on, including brave souls in Coventry challenging the archaic non-union recognising Amazon.

Despite the union organised strikes, there seems to be no joined up thinking to combine forces and bring about a more general withdrawal of labour.

They are all striking for their causes, and don't seem to be thinking beyond their own picket lines to the wider issues that cause spiralling inflation, obscene energy charges and corporate tax avoidance, overseen by a cabal of the ruling class in the guises of politicians, senior civil servants, church, state, monarchy, and the judiciary.

Talking of a cabal of the ruling class, Boris Johnson has reputedly earned over a million pounds in just six weeks in lecture fees and a healthy advance for his memoirs.

[30] Daily Telegraph.

At the same time he cost us, the taxpayers, around half of that amount again for legal fees related to his partying shenanigans.[31]

Oh, and his chums in the Tory party have just rushed through some anti-strike legislation. The bill maintains the right to strike (begrudgingly) but is intended to ensure public safety during walkouts. Or so they say.

During the latest wave of action ambulances and hospitals maintained essential services anyway and the postal service have kept up delivery of urgent medical supplies. It's just anti-union legislation designed to prevent the cooperation of working people, divide and conquer in other words.

Even Jacob Reece-Mogg called the anti-strike bill *"an extreme example of bad practice",* although I suspect his objections were more to do with the wording of the bill rather than its intention. I wouldn't put it past him to object because it fails to permit flogging for anyone who turns up for work with their cravat incorrectly tied.

On a brighter note, although not for us of course, Shell and BP have again announced record profits.

While their shareholders dance a stately minuet of joy around the parlour people are dying of hypothermia because they can't heat their homes.

We need to nationalise utility companies, against their will. Just do it. I know, big state = bad, but we need to protect people, working people, older people, the vulnerable and nearly everyone else while we are at it.

Whether we should encourage oil production is a separate issue, one I'm not going to get drawn into here except that instinctively I'm in favour of renewable energy over fossil fuels.

[31] The Independent, cross referenced with other news sources.

However we generate power, we should not let the utility companies be in the hands of private organisations.

One topic I am reminded of while writing this addendum, one overlooked in the main text (and I'm not doing another bloody revision) is that of collective action. Much as we should think and act as independent beings, free of the shackles of state, there is a good argument that cooperative action is effective.

In 1911 the city of Liverpool came to a standstill as workers went on strike, two were shot and killed by the army and hundreds injured as the government sent the troops in.

The Home Secretary at the time, one Winston Churchill, (the WW2 prime minister and racist, the man voted greatest Briton in 2002[32], and hero of the right) sent an armed warship up the Mersey ready to bomb the strikers.

The strike had spread though and troops couldn't be moved to where they were needed to break the strikes because the workers closed the railways.

The government gave in and "...*many strikers went back to work with better pay and conditions, and with a trade union movement transformed by the knowledge that, with resilience and solidarity, workers can win.*"[33]

The wave of industrial action during the winter of 2022 and into 2023 is mostly in unionised workplaces.

[32] Mind you, the same BBC survey placed Princess Di higher than Sir Isaac Newton, William Shakespeare, and Charles Darwin so maybe it said more about the people who respond to surveys.
[33] Quote and additional material from The Liverpool Echo, 7 Jan 2023.

Personally, I have mixed feelings about unions, I tend to think of them as a necessary evil, like wasps and aubergines, but I do understand that they have a job to do.[34]

Cooperation will be necessary, so long as we can avoid the tendency for unions to become self-serving edifices. Working cooperatively and for the greater good, we can win, as they did in 1911.

These days, it all seems rather bleak.

While we are scrimping and saving, switching to cheaper supermarkets, wrapping ourselves in blankets and skipping meals so the children can eat, the government and servants of the state and city are earing six figure sums, avoiding taxes, dusting off the crown jewels for a budget busting coronation and generally, you know, being the ruling elite.

In his foreword James mentioned that my proposals, which probably amount to little more than shoehorning a few giggles into a longwinded rant, although he's kind enough not to put it like that, may not be quick enough for many readers. He is correct, and they aren't quick enough for me either.

But, with age comes a certain degree of wisdom, or at least I like to think so, and part of my accumulated insight into the world, is that revolution is incredibly unlikely to happen, and if it were to ever come it would be bloody, chaotic and hurt those in need as much if not more than those in power.

Besides which if it fails the repercussions will be so draconian that we'll be longing for the 'good ole days' when only a handful died from hypothermia and those of us left had crippling debts and a government of tax avoiding self-serving wannabe aristocrats.

[34] I'm still not convinced about aubergines.

I'm also acutely aware that foreign interests will be circling like sharks around a floundering swimmer. Superstates like the USA, who already have a military presence in the UK of course, and Russia and China wouldn't like to miss out on the opportunity to exert more influence here.

These are states, not working people, who may be more oppressed in these countries than we are, for all our gripes against our own nation. China and Russia, and parts of the USA too, are no place for people who don't conform to their 'norms'. Try being in the LGBT+ community in Russia or a Muslim in China, to give just two examples.

None of which should stop us overthrowing the ruling elite here, maybe if we can do it, it can happen in those places and other counties too.

Again, I counsel a swift and bloody revolution, although a tempting thought, will not happen anytime soon. Let us instead start laying the foundations for change in our everyday actions and conversations.

I'm not, contrary perhaps to appearances, naïve. I know it's a long shot, but if ever the time was ripe for cooperation among the working people of the world, it is now.

And on that note let me acknowledge that since writing this addendum some of the examples I have used will have changed. Some strikes will have ended and other no doubt started. Such is the world. I must stop somewhere or this will never get published.

So, it is time for me bid you farewell with a heartfelt thank you for reading these musings.

I don't expect everyone (anyone) to agree with everything I have written, but food for thought is better than no food at all, and in Great Britain in 2023 no food is the reality for some, as it is for many working people around the world.

For a species that can put people on the moon, perform organ transplants and build a computer smaller than a grain of rice that is a fucking disgrace.

If the power isn't in your hands, then whose hands is it in?

Discuss, debate, cooperate, organise, rise up.

The revolution will be televised.

Don't forget to smile!

And that is that...

These essays are the product of a seething rage and impotency at the state of our nation that I'm sure I share with many readers.

You may think I've been misguided, ill-informed or just plain wrong. You might be correct, but as a wise man pointed out, that... *"would miss the point entirely. Life, and the politics that runs through our lives...shouldn't be some kind of ideological pissing contest; the (re)introduction of ideas, and the framing of them in a personable, thoughtful, but none-too-precious way, may provide an enjoyable gateway for readers to whom...radical texts might be a leap too far from a standing start."*

Anyway at least it is only on paper and not out loud. No one will ever know except us.

Thank you for reading, now, here's the inevitable self-aggrandising puff all about yours truly, or a version of me anyway.

"Oh, for goodness sake, not another bloody quote from the internet that's only tenuously connected to the text."

Editor
…Only one more page…

About the author

Born in London and raised in Hertfordshire and Suffolk, Ray was drifting through high school until he discovered punk rock. From then on, he spent his time nurturing a singular lack of musical ability, until realising too late that exam success might have been a better option.

Despite his abysmal school results, he went on to forge a career as a nurse, such was the desperation of the NHS in the early 80s.

In 2016 he and his wife Alison decided to leave the rat race, so they sold their home and spent the year living in a motorhome.

Life on the road re-ignited a desire to write that had never been entirely extinguished despite the best efforts of his teachers. His previous writing experience includes company annual reports, a punk rock fanzine and forging notes from his mother to excuse him from PE.

In 2018 he published his first book, *Downwardly Mobile*, documenting his and Alison's life on the road spending the best part of 2016 working at festivals and discovering the UK from the vantage point of their motorhome called Mavis.

After moving to the Isle of Mull and living in their motorhome Ray published the next instalment of his and Alison's adventures in *Still Following Rainbows*.

It documents the highs and lows of adjusting to life and work on a Scottish island, with snippets of history, vivid descriptions of the landscape and plenty of humour.

At the beginning of the Covid-19 lockdown in 2020, as if things weren't bad enough, Ray decided to raid his scrap book for unpublished articles, short stories and pieces cut from his other books and released *Even Unicorns Die - a collection of short stories, articles and assorted nonsense*, as an economy-priced diversion for everyone stuck at home.

These days Ray is officially a hypocrite. He works for someone with an unhealthy portion of the alphabet after his name, is a vegetarian who likes smoked salmon and hasn't read nearly as much radical literature as he'd like you to think he has.

He occasionally DJ's, owns an eclectic assortment of music and enjoys disc golf, writing and plotting to overthrow the government.

If you've a mind to contact the author you may do so here:

therevolution@email.com

Credits

Thank you as always to Alison for more inspiration and support than I could possibly give credit for here. Also, for her patience and editorial guidance beyond the call of duty.

James Domestic for invaluable advice, impromptu editing and generally being a good egg.
I highly recommend reading *Domesticated,* published by Earth Island Books, 2023, and listening to *East Anglian Hardcore* by The Domestics.
kibourecords.bigcartel.com

David Gamage and everyone at Earth Island Books, for taking a chance on this book and exemplary customer service.
earthislandbooks.com

Everyone involved with the Freedom website and journal, published by The Freedom Press.
freedompress.org.uk

I've used a variety of sources for background reading, research, and fact-finding. I've credited my principal sources as I've gone along. If I have omitted anything it's due to incompetence rather than spite.

The definitions used at the beginning of chapters come from dictionary.cambridge.org or languages.oup.com/google-dictionary.

That really is it.

Go away and change the world!

Printed in June 2023
by Rotomail Italia S.p.A., Vignate (MI) - Italy